ROYAL RUSSIA

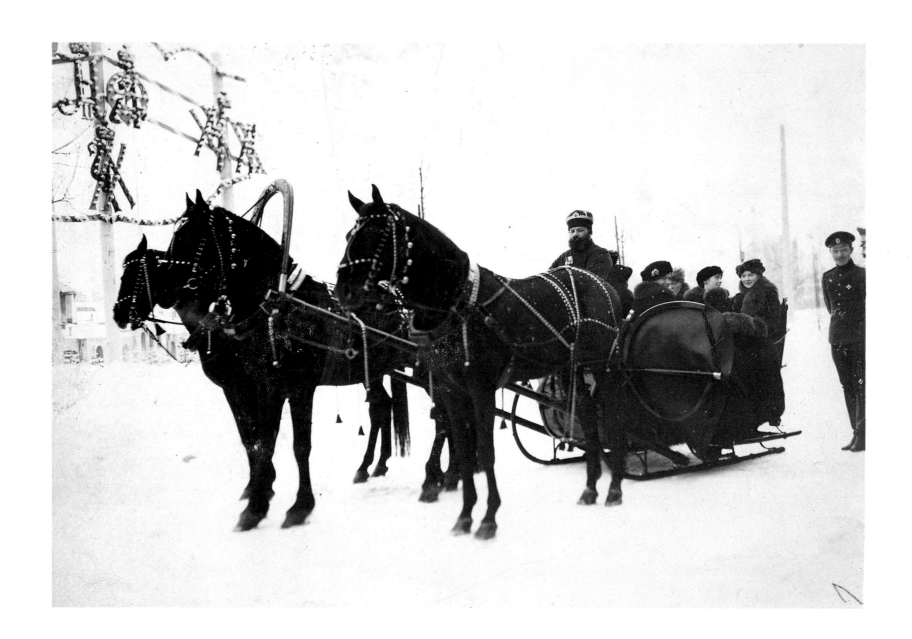

Royal Russia

FROM THE
JAMES BLAIR LOVELL ARCHIVE

TEXT BY
CAROL TOWNEND

ST. MARTIN'S PRESS ❧ NEW YORK

First published in Great Britain in 1995
by SMITH GRYPHON LIMITED
First U.S. edition: January 1998

ROYAL RUSSIA
Copyright © Text Carol Townend 1995
Copyright © Illustrations The James Blair Lovell
Estate/Ian Lilburn 1995

Designed by Hammond Hammond

ISBN 0 312 17936 7

Printed in Spain by Grafos SA

ACKNOWLEDGMENTS

Quite simply, you would not be viewing this book if several individuals had not been willing to take a risk and work at a worldwind pace to fulfil a dream of their deceased colleague and friend, historian James Blair Lovell. Prior to his death, James had identified several creative projects relating to the Romanovs. After his death, those of us working on the Literary Estate concluded that by combining what had been his current research and the archive, we could finish the picture album that James envisioned.

The James Blair Lovell Estate is deeply thankful to Robert Smith, Smith Gryphon Publishers, for taking over this project under unique circumstances and having faith in the outcome. Robert's patience and vision were vital. Not only has Claire Sawford of The Creative Umbrella been the estate's eyes and agent in London, but she has also been an encouraging friend who was never too busy to answer one more question coming from production neophytes in the USA. I'm sure Ian Lilburn never thought that James Lovell would be asking him to work once again on a Romanov project. Mr Lilburn has been very generous and gracious throughout this project. These creative participants have truly made a dream come true, and I know that James is thanking them in spirit.

KATHLEEN FRANZEN ON BEHALF OF THE
JAMES BLAIR LOVELL ESTATE

NOTE

The male heir of a Tsar and Tsarina is known as the Tsarevich, the Tsar's son. Other Imperial children are known as Grand Dukes or Grand Duchesses.

The titles Grand Duke and Grand Duchess are passed down one more generation, so a Tsar's grandchildren are also Grand Dukes or Grand Duchesses. A Tsar's great-grandchildren, however, only hold the rank of Prince or Princess. Thus Grand Dukes and Grand Duchesses outrank Princes and Princesses.

CONTENTS

INTRODUCTION

JAMES BLAIR LOVELL was a well-known historian. His major work, *Anastasia, the Lost Princess*, investigated the claim of the now deceased Anna Anderson that she was the Grand Duchess Anastasia of Russia – youngest daughter of Tsar Nicholas II.

Blair Lovell researched exhaustively, compiling an archive that is nothing less than a treasure trove of Romanov artefacts. The Imperial Family were enthusiastic photographers, and Blair Lovell's archive contains two albums once owned by them.

The first album belonged to the Tsar's third daughter, the Grand Duchess Maria, and is a record of the work the women of the Imperial Family undertook in the Palace Hospital during World War I. It is impossible to track it through time, but some landmarks are known. The Grand Duchess Maria gave the album to her childhood friend, Tatiana Botkin, daughter of the court physician, Dr Eugene Botkin, who was murdered alongside the Romanovs at Etakerinburg in 1918. In 1926, Tatiana Botkin met Anna Anderson and, convinced that she was the Grand Duchess Anastasia, gave her the album.

Blair Lovell unearthed the Grand Duchess Maria's album along with the second album, the Tsarina Alexandra's, in an auction lot of Romanov documents and memorabilia being put up for sale by a Russian emigré and collector, Alexei Miliukov. Miliukov knew Anna Anderson well. After Anna left Germany to settle in Charlottesville in the United States, Miliukov had been entrusted with shipping her possessions out to her. In return, he had been allowed to keep a few choice mementoes.

When Blair Lovell discovered the two albums, he recognized their value, and, in 1989, wanting to conserve them, he bought the entire Miliukov cache.

Additional photographs have been selected from the impressive private collection of Ian Lilburn, FSA (Scot), FRGS, research historian, and the only surviving observer of the Anastasia Appeal Instance court cases held from 1964 onwards in Germany.

Together, these three sources form *Royal Russia*, a unique compilation of over 140 photographs (many of which have never been published before). *Royal Russia* gives readers fascinating glimpses of the private and public lives of the last Tsar's family.

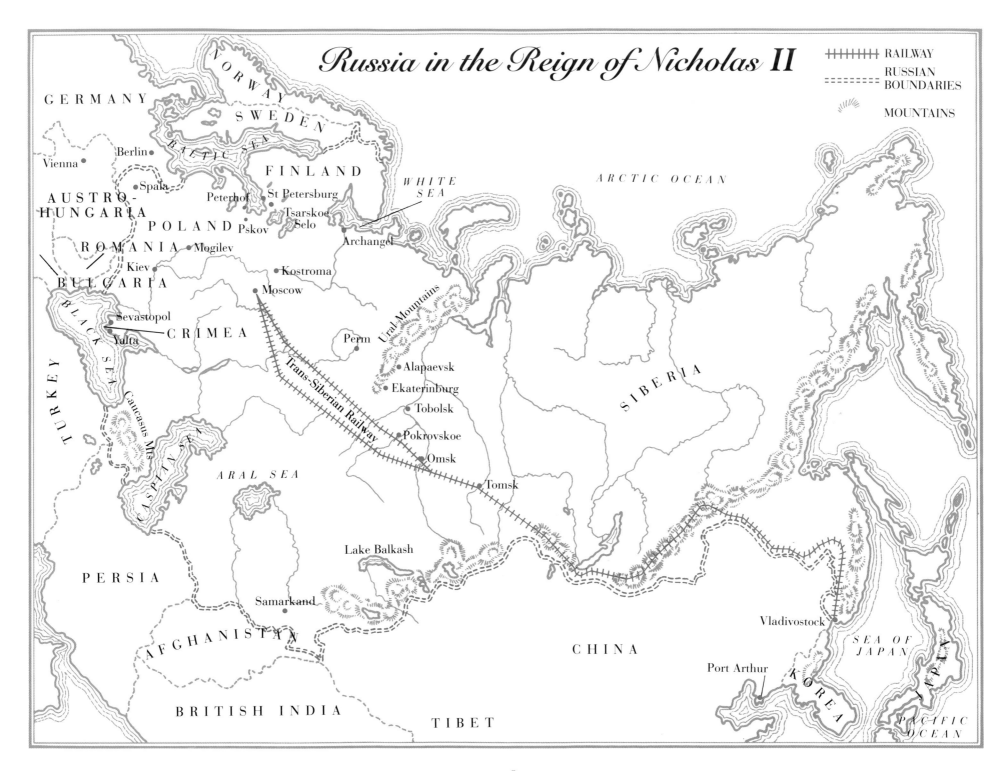

Russia in the Reign of Nicholas II

RAILWAY †††††††

RUSSIAN BOUNDARIES

MOUNTAINS

GERMANY

NORWAY

SWEDEN

BALTIC SEA

FINLAND

Vienna

Berlin

Spala

AUSTRO-
HUNGARIA

Peterhof

St Petersburg

Tsarskoe
Selo

WHITE
SEA

ARCTIC OCEAN

POLAND

Pskov

Archangel

ROMANIA

Mogilev

Kiev

Kostroma

BULGARIA

Moscow

BLACK SEA

Sevastopol

CRIMEA

Yalta

Perm

Ural Mountains

SIBERIA

TURKEY

Caucasus Mts

Alapaevsk

Ekaterinburg

CASPIAN SEA

Tobolsk

Trans-Siberian Railway

Pokrovskoe

Omsk

ARAL SEA

Tomsk

Lake Balkash

PERSIA

Samarkand

AFGHANISTAN

Vladivostock

SEA OF
JAPAN

CHINA

JAPAN

BRITISH INDIA

TIBET

Port Arthur

KOREA

PACIFIC
OCEAN

A DOOMED DYNASTY

THE RULE OF the Romanovs began in 1613. The previous thirty years, following the death of Ivan the Terrible in 1584, became known as the Time of Troubles and was a period of great turbulence. Desperate to stop the killing and destruction, the beleaguered Orthodox Church had called an assembly to elect a new ruler. They chose Michael Romanov, a boy of sixteen, of whom little was known save that he happened to be a grand-nephew of Ivan the Terrible. There was one drawback: no one knew his whereabouts.

Several months after his election, Michael was tracked down to Ipatiev Abbey, near Kostroma, where he had been living since his mother had taken the veil. Thus an unknown youth, Michael Romanov, became Tsar of Russia in February 1613. Some 300 years later the name Ipatiev would again be linked with the destiny of the Romanov house, but this time it would be associated with its destruction. However, for now order was restored.

During Michael's reign Moscow became capital of the Russian state. For the next two centuries the Romanovs' expansionist policy was staggeringly successful. The Ukraine was absorbed, as was territory in the fruitful southern lands of the Crimea. Peter the Great (*reg* 1696–1725) made Russia a leading power in the Baltic, creating a 'window on the west' and starting a relentless programme of modernization. He founded St Petersburg and transferred the capital there from Moscow.

However, the seeds of the expansionist policy's destruction were contained in its very success. Russia's far-flung borders were almost impossible to police. A huge army was required. The cost of this was punitive for a country that was still basically a rural peasant society, with at least four-fifths of the population living close to the land.

Russia's slow shift towards industrialization in the reign of Nicholas II's grandfather, Alexander II (*reg* 1855–81), was accompanied, on the one hand, by unrest among workers needing to determine their rights in the new factories and towns and, on the other hand, by landowners concerned for their vested interests.

An underground socialist revolutionary movement formed. Its aims were not only the destruction of tsarism but also the abolition of private property and the institution of marriage. The two opposing factions, socialist revolutionaries and reactionary landowners, became ever more polarized, and this was exacerbated because in Russia there was virtually no middle class to act as a buffer between them. Both the bloodshed in

the English Civil War in the seventeenth century and the violence of the French Revolution in the eighteenth were dire warnings of what might happen should no action be taken to lessen the tension between two such diametrically opposed groups.

Known as the Liberator Tsar, Alexander II's solution was reform. He freed the serfs in 1861 and worked steadily towards establishing a constitutional monarchy, modelled on those in Europe. For some, Alexander did not move quickly enough. For others, he was proceeding too fast in entirely the wrong direction.

Tsar Alexander had complications in other areas of his life as well. Although married to the Tsarina Maria Alexandrovna, who was suffering from tuberculosis, Alexander fell in love with a friend's daughter, Princess Catherine Dolgoruky. When Catherine's father died bankrupt, the Tsar arranged for Catherine's education, sending her to the Smolny Institute, a top-flight finishing school for aristocratic young ladies. Princess Catherine left the Institute at eighteen, and it was then that the Tsar declared his love for her.

Princess Catherine resisted Alexander for over a year, but an attempt on the Tsar's life in 1866 made her realize how much she cared for him. They became lovers and had children, to whom the Tsar covertly granted the titles of Prince and Princess Yurievsky. The fact that the Tsar had taken a lover was not in itself startling or unusual. But Alexander so adored his mistress that he scandalized the court by installing Princess Catherine in the Winter Palace, St Petersburg, alongside his wife, the ailing Empress Maria Alexandrovna. And only a month after the Empress died, Alexander married Princess Catherine in secrecy. She took the name Princess Yurievsky.

Politically, the conflict between conservatives and revolutionaries was coming to a head. In March 1881 a revolutionary group, the Nihilists, assassinated the Orthodox Alexander II using a bomb disguised as an Easter cake. When the bomb exploded at Alexander's feet, the young Nicholas was in the Winter Palace. Only thirteen, he witnessed his grandfather being carried in with one leg torn off and the other shattered, and blood from his abdomen making red trails down the corridors. He saw Princess Yurievsky fling herself across the body of her husband, heedless of the gore that soaked into her pink negligee.

This act of regicide made Nicholas heir to the throne. For a boy who had been taught that a Tsar had a mystical link with his people, it was an immense shock to discover that some of his subjects felt sufficient resentment to kill their ruler. Assassination was an occupational hazard for any political leader, especially a crowned head of Europe, and the threat of it was to hang over Nicholas's head for the rest of his life.

During his father's reign, in the winter of 1887 some university students hid a bomb in a medical textbook, with a view to assassinating Alexander III. The students were caught on the Nevsky Prospect in St Petersburg. In total fifteen conspirators were rounded up, five of whom were executed. Years later, in 1918, the Bolshevik Lenin was to exact a pitiless revenge on the Romanov family, one that involved even their children. And the reason Lenin burned for vengeance? Of those five executed students one had been Lenin's older brother, Alexander Yulianov.

Nicholas himself was the victim of an assassination attempt, which happened when he was Tsarevich (the Tsar's eldest son and heir) and in Japan on his Grand Tour during 1891. The Grand Tour was considered an

indispensable part of every gentleman's education; it broadened his mind and put the final polish on the man. Alexander had sent his son on tour not purely for educational reasons, however, but also in the hope that Nicholas would forget his desire to marry Princess Alix of Hesse. Alexander had another alliance in mind, one with France.

The attack happened at Otsu, Nagasaki, and the would-be assassin was a Japanese policeman. A religious fanatic, he was offended by some inadvertent breach of etiquette committed by the foreigners. He leapt out of the crowds, brandishing a sword and struck Nicholas on the head. Blood pouring from his wound and with no guards in sight, Nicholas fled down the street, only to be pursued. A companion, Crown Prince George of Greece, raced to the rescue, felling the policeman with a blow from a cane he had bought a few hours earlier. The Grand Tour was cut short, and Nicholas bore the scar of that attack to his dying day.

As pressure for reform built up, so the assassinations continued. Nicholas II's minister of the interior, Plehve, was assassinated in 1904. His uncle and brother-in-law, the Grand Duke Sergei, was assassinated in 1905. The list goes on.

The assassination of Alexander II, the Liberator Tsar, led to mumblings about Divine Retribution. The Tsar had sinned by installing his mistress in the Winter Palace and had compounded that sin by marrying her; God had punished him.

The new Tsar, Alexander III, decided that his father's liberal policies had encouraged the revolutionary activity that had killed him. He slammed the brakes on reform and tried to go back in time by imposing a rigid policy of repression. Alexander III has been described as being a 'Peter the Great with his cudgel'; he was also said to be 'just the cudgel without Peter the Great'.

By the time the last Russian Emperor, Tsar Nicholas II, came to the throne in 1894, the Russian state occupied one-sixth of the earth's surface, almost one million square miles in area. It had a population of 130 million subjects, with over 200 different nationalities. This sprawling empire was still an autocracy, its power derived from the idea that it was the duty of every subject to serve the state. The Tsar's power was absolute. There was no elected parliament, no House of Lords; everything fell on one man, the Tsar, who was not chosen on grounds of merit but by reason of birth alone.

No law could be changed without the Tsar's consent. No woman could sue for divorce; no peasant could so much as change his name, without the Tsar's consent. The system was bureaucratic, Byzantine and practically unworkable. The mountains of paperwork with which the Tsar had to deal were too much for one man. If Nicholas II wanted something as simple a carriage to be brought round, he couldn't just ask one of his footmen to send for one, he had to hand write a special order and sign it. At a time when Europe was moving towards full democracy, Nicholas II came to the throne utterly convinced that his powers had been entrusted to him by God and were inalienable.

Nicholas and Alexandra: Family Tree

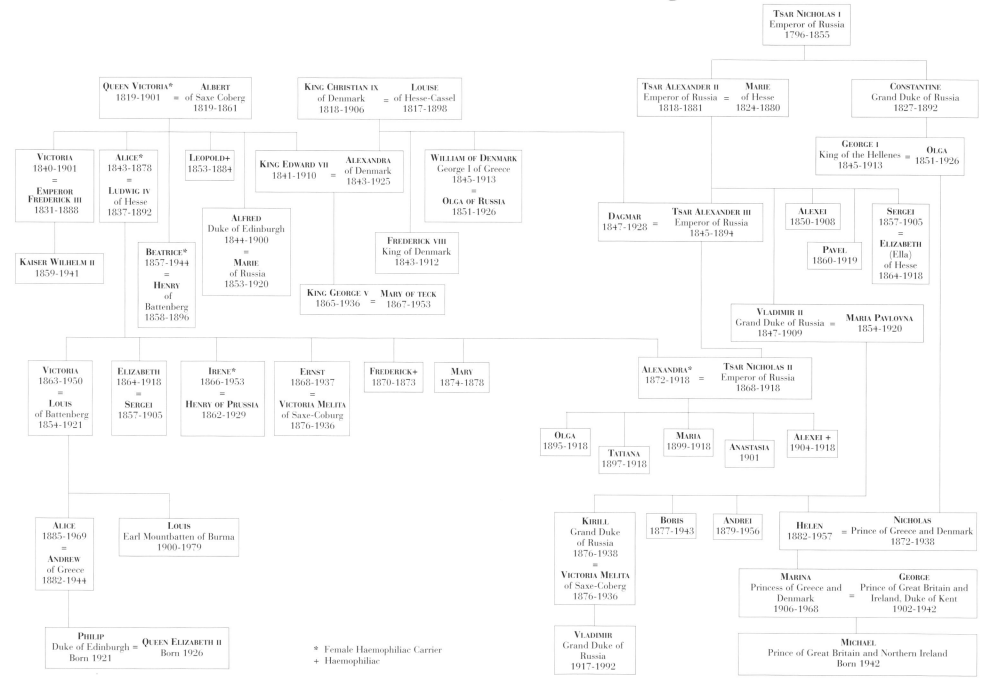

TSAR NICHOLAS I
Emperor of Russia
1796-1855

QUEEN VICTORIA*
1819-1901 = **ALBERT**
of Saxe Coberg
1819-1861

KING CHRISTIAN IX
of Denmark
1818-1906 = **LOUISE**
of Hesse-Cassel
1817-1898

TSAR ALEXANDER II
Emperor of Russia = **MARIE**
of Hesse
1818-1881 1824-1880

CONSTANTINE
Grand Duke of Russia
1827-1892

VICTORIA
1840-1901
=
**EMPEROR
FREDERICK III**
1831-1888

ALICE*
1843-1878
=
LUDWIG IV
of Hesse
1837-1892

LEOPOLD+
1853-1884

KING EDWARD VII
1841-1910 = **ALEXANDRA**
of Denmark
1843-1925

WILLIAM OF DENMARK
George I of Greece
1845-1913
=
OLGA OF RUSSIA
1851-1926

GEORGE I
King of the Hellenes = **OLGA**
1845-1913 1851-1926

ALFRED
Duke of Edinburgh
1844-1900
=
MARIE
of Russia
1853-1920

DAGMAR
1847-1928 = **TSAR ALEXANDER III**
Emperor of Russia
1845-1894

ALEXEI
1850-1908

SERGEI
1857-1905
=
ELIZABETH
(Ella)
of Hesse
1864-1918

KAISER WILHELM II
1859-1941

BEATRICE*
1857-1944
=
HENRY
of
Battenberg
1858-1896

FREDERICK VIII
King of Denmark
1843-1912

PAVEL
1860-1919

KING GEORGE V = **MARY OF TECK**
1865-1936 1867-1953

VLADIMIR II
Grand Duke of Russia = **MARIA PAVLOVNA**
1847-1909 1854-1920

VICTORIA
1863-1950
=
LOUIS
of Battenberg
1854-1921

ELIZABETH
1864-1918
=
SERGEI
1857-1905

IRENE*
1866-1953
=
HENRY OF PRUSSIA
1862-1929

ERNST
1868-1937
=
VICTORIA MELITA
of Saxe-Coburg
1876-1936

FREDERICK+
1870-1873

MARY
1874-1878

ALEXANDRA*
1872-1918 = **TSAR NICHOLAS II**
Emperor of Russia
1868-1918

OLGA
1895-1918

TATIANA
1897-1918

MARIA
1899-1918

ANASTASIA
1901

ALEXEI +
1904-1918

ALICE
1885-1969
=
ANDREW
of Greece
1882-1944

LOUIS
Earl Mountbatten of Burma
1900-1979

KIRILL
Grand Duke
of Russia
1876-1938
=
VICTORIA MELITA
of Saxe-Coberg
1876-1936

BORIS
1877-1943

ANDREI
1879-1956

HELEN
1882-1957 = **NICHOLAS**
Prince of Greece and Denmark
1872-1938

MARINA
Princess of Greece and
Denmark
1906-1968 = **GEORGE**
Prince of Great Britain and
Ireland, Duke of Kent
1902-1942

PHILIP
Duke of Edinburgh = **QUEEN ELIZABETH II**
Born 1921 Born 1926

* Female Haemophiliac Carrier
+ Haemophiliac

VLADIMIR
Grand Duke of
Russia
1917-1992

MICHAEL
Prince of Great Britain and Northern Ireland
Born 1942

Star-crossed Lovers

'MY GOD! MY GOD! What a day! The Lord has called our adored, precious, fiercely beloved Papa to him. My head is spinning.'

This is how the new Tsar, Nicholas II, recorded his feelings in his diary in October 1894 on the day his father died. Privately, on that same day, he wept on the shoulder of his brother-in-law, the Grand Duke Alexander.

'Sandro, what am I going to do?' he asked. 'What is going to happen to me, to you, to Alix, to mother, to all of Russia? I am not prepared to be a Tsar. I never wanted to become one. I know nothing of the business of ruling. I have no idea of even how to talk to the ministers.'

This was not an auspicious beginning for a new reign. At twenty-six Nicholas was no longer a child. He had been heir to the throne for thirteen years. Time enough to prepare himself for the business of government.

Grieving for his father, Nicholas decided that his wedding to Alix, Princess of Hesse, should be brought forward. Alix was a guest of the Imperial Family at Livadia, so it could be arranged quickly.

Princess Alix, a daughter of the Grand Duke Ludwig IV of Hesse, had been born in Darmstadt, capital of her father's small German state, in 1872. Darmstadt was a tiny town nestling in a misty valley on the River Rhine, but it already had important links with the Imperial House of Russia. Maria Alexandrovna, the spurned wife of Alexander II, had been a princess of Hesse. And in Alix's generation, her sister Ella was married to Nicholas's uncle, the Grand Duke Sergei.

The first time Alix visited Russia had been in 1884 for her sister's wedding. It was also her initial meeting with Tsarevich Nicholas. Alix and Nicholas had been attracted to each other immediately, and in Peterhof, at the Imperial dacha, or villa, at Alexandria, they had scratched their names on a window pane with a gem on Alix's ring. By 1891, Nicholas was writing in his diary that it was his 'dream to get married one day, to Alix of Hesse'.

Princess Alix was closely related to the British Royal Family. Her mother, Alice, had been one of Queen Victoria's daughters. Alice died of diphtheria when Alix was only six, and subsequently Alix spent much of her time in England. She was Queen Victoria's favourite grandchild. However, Queen Victoria bestowed a malign legacy on Alix. The Queen was a carrier of haemophilia. Female carriers do not show symptoms of this deadly disease, but they can pass it on to their male offspring. In those days it was incurable. The Queen's daughter Alice had been a carrier. So, too, was Alix. Thus any son of hers might be a haemophiliac. Queen Victoria had lost a son to this disease, which became a taboo subject in her lifetime, and the question of haemophilia was never raised during Nicholas's courtship of Alix. Other problems did have to be overcome, however.

Firstly, Tsar Alexander opposed the union, sending Nicholas on his Grand Tour, hoping that he would forget about the Princess of Hesse. But Nicholas did not do so, and in the spring of 1894, when the ruler became seriously ill with kidney trouble, it was decided that the time had come for the heir to the throne of Russia to be married. Nicholas could have his way.

Secondly, there was the question of religion. Russia had been converted to Christianity in AD 988, but in the form

practised by the Byzantine Orthodox Church. A Russian Empress had to be of the Orthodox faith. If Nicholas and Alix were to be married, it would be necessary for Alix to convert.

In April 1894, Alix's brother, Ernst, Grand Duke of Hesse, was married in Coburg. Most of the crowned heads of Europe attended the ceremony, including Queen Victoria and her thirty-five-year-old grandson, Kaiser Wilhelm II of Germany. The Tsarevich Nicholas brought three of his four uncles: the Grand Dukes Vladimir, Sergei and Pavel. It was understood that Nicholas would propose to Alix. In the Russian party, hoping for a favourable answer, was Catherine Schneider, the tutor who had taught Russian to Alix's sister Ella. A priest, Father Ioann Yanyshev, was ready to instruct the German Princess in the Orthodox creed.

Nicholas proposed, but Alix refused him, on religious grounds.

Nicholas persisted. Kaiser Wilhelm of Germany and Ella supported his suit, and the following day, after her brother's wedding, Alix capitulated. This is how Nicholas recorded her acceptance in his diary:

'A wonderful unforgettable day in my life – the day of my engagement to dear beloved Alix ... God what a mountain has lifted from my shoulders. The whole day I've been walking in a sort of trance.'

Not everyone was quite as ecstatic about their engagement. In May 1894, Queen Victoria expressed her misgivings in a letter to her daughter Victoria:

'The more I think of sweet Alix's marriage, the more unhappy I am! Not as to the personality, for I like him very much, but on account of the country, the policy and differences with us and the awful insecurity to which that sweet child will be exposed.'

Despite her objections, Queen Victoria wrote regularly to her granddaughter until her death in 1901.

Alix of Hesse loved pearls, and Nicholas's engagement gifts took account of this – a pink pearl ring and necklace, as well as an emerald bracelet and a sapphire and diamond brooch. And, as a gift from the Tsar and Tsarina of Russia, Alix received a string of pearls worth 250,000 gold roubles, which had been created by Fabergé, the Russian court jeweller. After their engagement in Coburg, Nicholas and Alix had to be separated, but they wrote to each other every day. Each letter was numbered, and a marvellous correspondence began, one that was to continue whenever they were apart for the rest of their lives – 24 years in all.

Tsar Alexander III was expected to reign for many more years, but in October 1894, at the palace of Livadia in the Crimea, Alexander died of nephritis, an inflammation of the kidneys. Nicholas, now Tsar Nicholas II, was far from ready to step into his shoes, and much of the blame for this could be attributed to his father.

Alexander III had been a colossus of a man with the strength of Hercules and a taste for vodka. He could bend pokers with his bare hands and tie forks in knots. In 1888, when the Imperial train crashed at Borki and the roof of the family's carriage caved in, Alexander was able to hold up the roof while his family clambered to safety. The strain of supporting that carriage roof did irreparable damage to his kidneys, and six years later this caused his death. Thinking to spare his heir the cares of state for as long as possible, Alexander had given his son the education of a European gentleman. The Tsarevich Nicholas had served in the army, first as a subaltern and then as a company commander in an infantry regiment – the

Preobrazhensky. Next he served in the Hussars, before being made Colonel of the Horse Guards Artillery.

Nicholas enjoyed the army, forging loyalties that were to serve him well in the turbulent years ahead. He adored pageantry and ceremonial, and the life of an officer suited him. Nicholas was an outdoor man, and physical exercise was to be a necessity all his life. He hunted with friends. He visited the opera. Champagne flowed, so much so that the Tsarevich occasionally suffered from a *bashka*, a terrible head.

As Tsarevich, Nicholas had visited the St Petersburg ballet school and had met the ballerina Mathilde Kshessinska. An affair began, but his relationship with the dancer ended abruptly on his engagement to Alix. At the time of the Revolution, Kshessinska fled Russia. She married the Grand Duke Andrei in Cannes in 1921 and set up a ballet school in Paris, for a time instructing Margot Fonteyn. At the age of 63, she was to dance at Covent Garden. She died in 1971, having almost reached one hundred.

Nicholas travelled widely, but he was taught very little about politics. Alexander thought there would be plenty of time during the next ten years or so to burden his son with the cares of state. This could wait until after Nicholas had married and begun his family. But, as we have seen, Alexander had miscalculated.

The suddenness of Alexander's death meant that his heir was dangerously naïve when it came to politics. Nicholas was well meaning and diligent, but he did not have the first idea how to govern Russia. It was Nicholas II's great misfortune that he was called upon to steer his country through one of the most turbulent periods of her history, when he was ill suited to the task by both temperament and training.

Meanwhile, as the warships in Yalta harbour boomed out a last salute to the dead Tsar, Nicholas was insisting his marriage be brought forward. He and his mother wanted the ceremony to be held quietly at Livadia, but his uncles, the Grand Dukes to whom Nicholas was to turn for advice so much in the first ten years of his reign, decreed the wedding must take place in St Petersburg.

Alix was not yet Orthodox. So, while the embalmers were readying Alexander for his coffin, and a storm raged on the Black Sea, a hasty ceremony was arranged. Alix converted. As was traditional, Alix took a new name and title with her new religion: the Grand Duchess Alexandra Feodorovna. Thus, when Alexandra rode into St Petersburg, she came in at the tail of the funeral train and earned another name, 'the funeral bride'.

Nicholas and Alexandra's wedding followed a whole week of funeral rites. Mourning was set aside for the day, but the bride was to write that the wedding did seem 'a mere continuation of the masses for the dead with this difference that now I wore a white dress instead of a black'.

Despite this ominous start, Nicholas and Alexandra were happy together. It was joy rendered all the more poignant because it was mixed inextricably with the grief surrounding Alexander's death. Pure happiness was something the Imperial couple rarely experienced. All the important events in their lives were to be tinged with sorrow. This was to be especially true when the heir they longed for, the Tsarevich Alexei, was finally born.

The Children of Tragedy

NICHOLAS AND ALEXANDRA'S wedding had taken place in 1894 in St Petersburg, the Venice of the North, the modern capital founded by Peter the Great, where the waterways froze solid in winter and were used as highways by both sleighs and people. Alexandra went into labour with her first child in November 1895. Everyone hoped for a son, an heir for the Romanovs. There was to be a 300-gun salute if the child were a boy, or a 101-gun salute if the child were a girl. The baby was a girl, the Grand Duchess Olga.

Russian coronations took place in the more traditional setting of Moscow. Moscow had been at the heart of the Russian soul ever since a stockade was thrown up around the medieval citadel of the Kremlin in the twelfth century. It was the 'City of Forty Times Forty Churches'. The skyline bristled with towers. The air rang with church bells and was fragrant with incense. Blue and gilded onion domes gleamed above green rooftops, and the backstreets were a labyrinth of wooden houses and cabins.

The five-hour Coronation service in 1896 in the Uspensky Cathedral was for both Nicholas and Alexandra a symbolic and mystical experience. Once crowned, Nicholas was God's representative on earth for his Orthodox subjects. The Coronation bound Nicholas with God and his people in an indissoluble link that would last to the grave. He was 'Father' of the Russian people and Alexandra their 'Mother'. People would pray to the Tsar, some believing he had the power of healing, and if they could but touch him, they would be cured.

At his Coronation, Nicholas accepted responsibility for the fate of his Empire. He was convinced that God in His wisdom had chosen him for the role of Tsar, knowing all his faults and weaknesses, and as God was all knowing, His wisdom could not be questioned. This reasoning was one of the roots of Nicholas's attitude to politics, and many a disagreement with ministers would grow from it. If Nicholas felt in his heart that such and such a policy was wrong – whatever proof ministers might offer to the contrary – then he, the autocrat, would follow his heart. He was God's chosen, and God would protect His instrument, Nicholas, against the forces of chaos ranged against him. This confidence was to serve him badly in the decades ahead.

The Coronation festivities were ruined by a tragic accident, the stampede at Khodynka Field. It was the custom for a new Tsar to give food and mementoes – enamel mugs stamped with the Romanov double-headed eagle – to his people. Ella's husband, Grand Duke Sergei, was entrusted with organizing this, and Khodynka Field was chosen as the distribution site. Over half a million people gathered, but a rumour spread that the gifts were in short supply. Panic swept through the crowd. People rushed at the stalls and, being pushed from behind by others, trampled on any who stumbled. Hundreds suffocated in the crush. It is thought that over 1000 people were killed, and 9000 hurt, but estimates vary widely. Nicholas and Alexandra spent the rest of the day visiting the injured in hospital after hospital.

That evening a ball was to be held in their honour at the French Embassy. Tapestries and silver plate had been imported especially from Versailles and 100,000 roses from the south of France. Nicholas and Alexandra's

instinct was not to attend. Their wishes, however, were overruled by Nicholas's uncles, who for political reasons did not wish to offend their allies, the French. Swayed by the advice of the Grand Dukes, the Imperial couple attended and led the first quadrille. Alexandra's face was swollen with tears, but as far as the mass of the Russian people were concerned their decision was disastrous. Surely the new Tsar and Tsarina must be heartless, to dance the night away after Khodynka Field? They were never forgiven this error in judgement. The reputation of the new Father and Mother of the Russian people was badly tarnished.

After the Coronation, Nicholas and Alexandra went on a tour of Europe. Baby Olga accompanied them and was shown to Alexandra's grandmother, Queen Victoria, at Balmoral. Alexandra had always been painfully shy. As a girl, after her mother's death, much of her education had taken place in England. Queen Victoria had tried to help her overcome her reserve at the English court, by encouraging her to play the piano in company. But the shyness persisted. In Russia Alexandra felt even more ill at ease and out of place. The Russian court was extravagant and sophisticated, and the morals of some of the aristocracy shocked her English-bred Lutheran nature. When Alexandra was uncomfortable, she held herself stiffly, and vivid splotches appeared on her neck and arms. People mistook her shyness for aloofness and thought her haughty.

For his part, Nicholas had no great liking for court life. He preferred to live more quietly in one of his palaces in the country. The tranquil life of a country gentleman was his ideal. Owing to dynastic inter-marriages with the great houses of Europe very little Russian blood flowed in Nicholas II's veins. He was more European than Russian, but he believed passionately in the mystical link between him and his people – the Russian peasantry – and could not see that he was separated from them by an impassable gulf. Although French was the language of the court, the Tsar insisted that ministers report to him in Russian. He spoke Russian to his children and liked to wear a peasant-style Russian tunic, with baggy breeches and boots. He preferred simple Russian fare, such as buckwheat porridge, or borsch with sour cream, or perhaps cabbage soup with rye bread and salted cucumber. Unlike his father, Nicholas II was not a great vodka drinker, enjoying instead the occasional glass of madeira.

Gradually the Tsar and Tsarina retired from court life, a decision that unwittingly weakened the crown's influence on the Russian élite and further distanced them from the political life of their Empire.

Nicholas and Alexandra had seven palaces in which to live and over 15,000 servants and officials to command. They made their main home at Tsarskoe Selo, the Tsar's village, about 15 miles outside St Petersburg. This huge park, a world within itself, was patrolled night and day by Cossack guards and had within its iron railings two Imperial palaces. The Tsar and Tsarina chose the smaller one, the Alexander Palace, for their home, and Alexandra decorated it to her taste, English Victorian. Alexandra's boudoir was decorated in mauve, her favourite colour. The Chippendale drawing-room was pale green.

In 1897 Alexandra gave birth to a second daughter, the Grand Duchess Tatiana. Two more girls followed: the Grand Duchess Maria in 1899 and the Grand Duchess Anastasia in 1901 – the year Queen Victoria died.

The four Grand Duchesses were brought up strictly, following the English customs that the Tsarina had learnt

from her grandmother. They had a cold bath every morning and a warm one every evening. They slept on hard camp-beds, without pillows, and were to sleep in these beds all their lives, even taking them to Ekaterinburg, where they slept in them on that last night in 1918.

Family life – apart from the fact that there was as yet no heir – was happy. Alexandra enjoyed motherhood, knitting baby clothes for her children and insisting on nursing them whenever they were sick. She nursed Nicholas, too, through a bout of typhoid in 1900, staying up night and day and working herself to the brink of exhaustion. Already nervous and highly strung, Alexandra undermined her own health by this tendency to overwork herself when her family were ill. It weakened her delicate constitution.

The family spent their summers in Peterhof, at the Alexandria Palace. For two weeks every June they would cruise around the Gulf of Finland, visiting the fiords or picnicking in the Finnish forests.

The Tsar had a fleet of yachts. His favourite was the *Standart*, a steamer that he had specially commissioned from a Danish shipyard. It had three masts and two funnels, and its decks were canopied with white awnings and lined with wicker tables and chairs. The drawing-rooms, lounges and dining-rooms were panelled with mahogany. Crystal chandeliers tinkled overhead, and velvet drapes swung gently in time with the rocking of the sea. The family's staterooms were decorated in chintz. There was a chapel and a brass band.

Wherever she went, Alexandra prayed constantly for a son, visiting shrines, and consulting holy men and women. In 1904 she became pregnant once more and went into labour with her fifth child. This time the guns boomed out the 300-gun salute. At last the Romanov heir she and Nicholas had longed for had been born, the Tsarevich Alexei. The Imperial couple's joy was unbounded. Picture postcards of the Tsarevich Alexei were made in their thousands and distributed to the Imperial troops.

Then Alexandra noticed an ominous bleeding from the baby's navel, which did not heal. The Tsarevich bruised easily. She and Nicholas began to suspect that their son was a haemophiliac, and their joy was mixed with fear. A haemophiliac's blood does not clot properly; if cut, they can bleed to death. Should they fall, the resulting internal bleeding can cause bruising and intense pain. At the time haemophilia was still incurable. It was two years before haemophilia was definitely diagnosed. Nicholas and Alexandra decided that no one but the immediate family and their private physicians were to know.

Alexandra never forgave herself for passing the disease on to her son and found it impossible to accept that he could not be cured. Always, she hoped for a miracle. She collected icons, up to 800, in her bedroom. Her religious fervour increased as she became more desperate. Alexandra had St Theodore's Cathedral built especially to pray for Alexei in Tsarskoe Selo. She went there regularly to invoke the saints' help.

As Alexei grew, two sailors from the *Standart*, Derevenko and Nagorny, were employed to keep an eye on the Tsarevich, to ensure he didn't hurt himself. Alexei was not left unattended for a second.

Mystics and Bolsheviks

IN 1905 ALEXANDRA'S FRIEND Anna Vyrubova introduced her to the bearded, hypnotic-eyed Grigori Efimovich, otherwise known as Rasputin. Nicknamed the Cow, Anna came from a distinguished family. Her father was Director of the Imperial Chancellery as well as being a composer. Rasputin had very different roots, he was a *moujik*, or peasant, from Pokrovskoe in Siberia.

In Rasputin, Alexandra felt that her faith had been rewarded. She had found her 'miracle' worker. She was to pay a terrible price for her relationship with him – it was to create a rift that would tear the Imperial Family apart and contribute to the downfall of the Romanov dynasty.

Rasputin was a *starets*, a holy man – not a priest or a monk, but someone with immense moral authority. As a youth Rasputin had a reputation for hard drinking – in Russian, Rasputin means 'dissolute'. He'd been caught thieving several times, but his life changed after a visit to a monastery in the Urals. Almost illiterate, Rasputin came to exert great influence on Alexandra, who treasured his words as though they were holy writ, recording his prayers in her diaries. Rasputin was married, to a peasant woman who bore him two daughters and a son.

Initially, Alexandra's encounters with Rasputin were rare, but as Rasputin established a reputation for wisdom and healing, so his meetings with the Tsarina became more frequent. They usually met at Anna Vyrubova's house in Tsarskoe Selo. The following episode goes some way to explaining Alexandra's dependency on Rasputin.

In 1912, in Poland, Alexei banged his leg when climbing out of a boat near the Tsar's shooting-lodge at Spala. Internal bleeding began, and the Tsarevich's health rapidly deteriorated. Both Dr Botkin and Dr Derevenko (no relation to the sailor Derevenko) seemed powerless to help him. Rumours spread that the heir was fading fast, and although people did not know the nature of the Tsarevich's illness, all over Russia the faithful prayed before icons for his recovery. Journalists speculated wildly – the London *Daily Mail* stating that he had been the victim of an anarchist's bomb attack.

For eleven days and nights, Alexandra stayed up with her son, stealing the odd moment's rest on a couch in his room, while pretending to the outside world that all was well. The family thought Alexei was bound to die. In despair, Alexandra telegraphed Rasputin, who was far away across the Siberian forests and steppes, in Pokrovskoe.

Her 'Friend' telegraphed back a reply: 'God has seen your tears and heard your prayers. Do not grieve. The Little One will not die. Do not allow the doctors to bother him too much.'

A few days later the turning-point came. Alexei recovered. The Imperial doctors were utterly bemused. There was no medical explanation for the Tsarevich's mysterious recovery. Rasputin had not even been present. Meanwhile, the outside world, not understanding the reason behind Alexandra's dependence on Rasputin, was

growing increasingly suspicious about his influence on the Imperial Family. For some time the secret police had had Rasputin under surveillance; they had made a record of his carousings, and of the prostitutes and other women who visited him in his lodgings, often staying the night there. Rasputin's reputation for lasciviousness grew. So did the details in the police report. Obscene caricatures were discovered circulating around St Petersburg, depicting the Tsarina Alexandra as the lover of both Rasputin and her friend Anna.

The Tsar's supporters, the monarchists, were infuriated by these attacks on the monarchy. They decided to put an end to the rumours by opening the Tsar and Tsarina's eyes to Rasputin's nature. If Nicholas and Alexandra saw the other, dark, side of Rasputin, surely they would sever their connections with him? The Tsar's close family were involved in this, and it was the Grand Duke Nikolai Nikolaevich who presented the damning report on Rasputin to the Tsar.

Nicholas spotted an error in the report's findings. On one of the days when Rasputin had been implicated in a debauch at a restaurant, the *starets* had in fact been at Tsarskoe Selo, talking to Nicholas and Alexandra. Nicholas II was a stickler for accuracy, and as far as he was concerned this mistake put the authenticity of the entire report in question. He refused to act on it, understanding that Alexandra's reliance on Rasputin went too deep for her to cut her ties with him. Meanwhile, Alexandra dismissed the charges as black lies, trumped up by Rasputin's enemies who were, she believed, jealous because he received Imperial favour.

More grotesque caricatures of Alexandra and Rasputin were seized. The monarchists were in despair. Drastic action was called for. But what?

Reactionary members of the aristocracy were not the only disgruntled members of society during Nicholas II's reign. Russia in the later nineteenth and early twentieth century was riven by inequities and competing interests. When Nicholas took his Coronation oath in 1896, he found himself caught in a catch-22 situation, one that essentially put him at war with himself.

If the Russian Empire were to survive as an effective power internationally, and naturally this was one of the Tsar's aims, Russia must be modernized as quickly as possible. She had to keep pace with other urban and industrial powers. But too speedy a modernization was likely to rock the boat at home. Domestic instability could weaken the power of the autocracy, especially if it accepted the changes demanded by its rapidly evolving society. Thus any proposal that meant altering the status quo was regarded with great suspicion and was strongly resisted as running counter to the interests of the autocracy. In essence, the interests of Russia as an empire and the interests of the Romanov autocracy often conflicted. This conundrum was essentially the one that had faced Nicholas II's grandfather, Alexander II, as well as his father, Alexander III. There was no easy and painless solution.

When Nicholas ascended the throne, it was hoped that he, as a younger monarch, might be open to reform. But Nicholas leaned heavily on his uncles and mother for advice, especially in the first ten years of his reign. And

the views of his uncles coincided almost exactly with those of Nicholas II's late father. The Grand Duke Sergei, Governor General of Moscow, for example, felt so threatened by change that he banned his wife, Ella, from reading Tolstoy's *Anna Karenina* in case it should arouse 'unhealthy curiosity and violent emotions' in her. Thus Tsar Nicholas, instead of welcoming innovative theories to usher in a modern Russia, followed the lead of conservative advisers.

Outside the Imperial circle, Russian liberal attitudes had been filtering through to the arts for some decades. In *Dead Souls*, where he described the appalling lot of the serfs, Gogol had already depicted the Russian gentry in an unfavourable light. His work had been banned as far back as the 1840s. There was Dostoevsky, too, who at one time had been sentenced to death for reading subversive literature. His sentence had been commuted, and he was exiled to Siberia before being pardoned by Alexander II.

Now, under Nicholas II, Anton Chekhov was beginning to write short stories and plays expressing disillusionment with the Tsar's régime, and the concepts and policies on which it was turning its back.

The Tsar's income was 24 million gold roubles, revenue that came partly from taxes and partly from the vast acres of Crown Lands. His Imperial regalia were breathtaking. Apart from the Russian Imperial Crown, there was the Orlov diamond, which Catherine the Great had set in the Imperial Sceptre. The Orlov diamond had come into Russia from Persia, stitched *inside* the thigh of an Armenian smuggler. Another priceless diamond, the Moon of the Mountain, and a ruby, the Polar Star, were but part of the Imperial treasure.

And yet, in the same country, rural schoolteachers were paid just at or below subsistence levels. Scrabbling around to save their last kopek, they often lived in huts among the peasants' cattle, permanently on the verge of starvation. Millions of people lived in similar, punitive conditions; kept in place by a religion that stressed a God-ordained hierarchy and by a relatively small élite that had the backing of the army. The army was largely made up of conscripts who had been frog-marched away from their villages and farms. They cared little for Romanov policies but lived in fear of the Cossack whip – the *nagiaka*. Russia was ripe for revolution.

The Nihilists who had assassinated Nicholas II's grandfather, Alexander II, had been all but wiped out. But, like the legendary dragon's teeth, new revolutionary groups had sprung into existence, and these gave voice to the grievances of the repressed and downtrodden masses. The most notable were the Social Democrats, who embraced a new doctrine – Marxism. A split in the leadership of the Social Democrats divided the group into two: Mensheviks and the more extreme Bolsheviks.

Lenin, whose brother had been executed for plotting to kill Alexander III in 1887, assumed leadership of the Bolsheviks. Seeing so many of his fellow revolutionaries had been executed or exiled to the frozen wastes of Siberia, Lenin decided his cause would be better served if he worked in exile. He went to Switzerland, living in poverty while he laboured behind the scenes, writing and drumming up support. Lenin bided his time until the spring of 1917, when he returned to Russia just after Nicholas abdicated. His time for revenge had arrived.

End of the Empire

AS RUSSIA ENTERED the twentieth century, the days of the opulent St Petersburg court were numbered, but despite intense pressure from outside for radical reform, the Season managed to stagger on for a few years.

The Season began on New Year's Day and continued throughout the winter months till Lent. While the ice was feet thick on the River Neva, and factory workers shivered in dismal, ill-lit lodgings, the aristocracy shrugged on thick furs, climbed into their sleighs and flew off to ball after glittering ball.

A *Bal Blanc* was attended by unmarried girls accompanied by hawk-eyed chaperones. The girls wore virginal white and danced quadrilles with young officers in glittering high-ceilinged ballrooms lit by crystal chandeliers. A *Bal Rose* was for young married couples and was far less sedate. At a *Bal Rose* couples waltzed in each other's arms past gilded mirrors, or danced wild mazurkas round potted palms to the accompaniment of gipsy violins.

For the privileged élite, there were concerts where the works of Tchaikovsky, Rimsky-Korsakov and the more avant-garde Stravinsky were played. There were operas and ballets, banquets where armies of servants silently proffered glasses of champagne on silver salvers. There were exotic fruits from hothouses in the south, orchids flowering in Chinese vases and caviare aplenty.

The highlight of the Season was an exclusive reception held at the Winter Palace. Nicholas and Alexandra had no great liking for formal assemblies and would usually slip away as early as they could. The last of Nicholas and Alexandra's grand pageants was held at the Winter Palace in 1903. It was a fancy-dress ball, and guests wore seventeenth-century costume. Copies of the court dress worn by Tsar Alexei Mikhailovich and his consort were made for Nicholas and Alexandra. The brocade was studded with gems, and Fabergé designed a necklace for Alexandra in the old style, using one of the largest sapphires in the world. Other guests came as *boyars* (hereditary nobles) and *boyarinas* of the period, and they joined in dances of ages past.

Only the next year, in 1904, Russia was sucked into a disastrous war with Japan, and in 1905 'Bloody Sunday' marked the beginning of the Revolution. Court life would never be the same again. The events of Bloody Sunday began peaceably with unarmed workers marching on the Winter Palace. Led by a priest, Father Gapon, they intended to present a petition containing 135,000 signatures asking for civil rights. There was a holiday atmosphere, and demonstrators held the Tsar's portrait aloft, alongside icons and banners.

Normally cavalry and Cossacks – who used whips and the flats of their sabres – were used to control demonstrations, but this time the troops were called out, infantrymen who had no experience of crowd control. They were to panic and open fire. Over 100 people were killed, and many more were wounded. Some put the death toll much higher, at between 2000 and 4000. Nicholas, who was not in the city at the time, wrote in his diary:

'A sad day. In Petersburg serious disorders occurred as a consequence of the workers' wish to reach the Winter Palace. The troops had to open fire in various parts of the town and there were many killed and wounded. Lord, how painful and sad.'

The events of Bloody Sunday sparked off a year of terror. Three weeks later, Grand Duke Sergei, the Tsar's uncle and Ella's husband, was assassinated in Moscow. Loathed as a notorious persecutor of Jews and feared as Governor General of Moscow, Grand Duke Sergei had enemies everywhere.

From her apartment in the Kremlin, Ella heard the explosion. She knew immediately what had happened and ran out into the snow, but she could not find Sergei, only pieces of bleeding flesh, including a hand and a foot. Her husband's head was never found. Later, Ella visited Sergei's assassin in prison and offered to plead for his life.

Ella and Sergei never had children since Sergei was homosexual; but Ella loved her husband, and his sudden, violent death transformed her. She built the convent of SS Mary and Martha in Moscow and became its abbess, wearing the white habit of a nun for the rest of her life. Taking the veil did not save Ella in 1918 when the Bolsheviks prised her out, sending her to Alapaevsk in the Urals, where they killed her and several other of the Tsar's relations by flinging them alive down a mine shaft and throwing timbers and hand grenades in after them.

In October 1905, after Sergei's assassination, a general strike gripped St Petersburg. The electric lights went out. Food deliveries stopped. Nicholas summoned the first elective assembly, the 'Duma'. It seemed that Russia was moving towards a constitutional monarchy, but the path was a thorny one and was to double back on itself and change course several times.

The St Petersburg workers formed the first Soviets, or councils. Agitators continued to work among the students, of whom one in ten was suspected of being a police informer. Suspicion and hatred grew.

In 1906 almost 400 agitators had been executed, ensuring that the name 'Bloody Nicholas' went down in history. Many other dissidents were exiled, but several of Nicholas's supporters thought he was being too lenient.

Stalin, Lenin's man in St Petersburg, launched the underground newspaper *Pravda* [Freedom] in 1912. It survived for two years before Stalin was caught and exiled to Siberia. The autocracy had triumphed, or so it seemed.

By 1913 the Romanovs were celebrating 300 years of rule. The Tercentenary Celebrations were elaborate and prolonged, with the Imperial children taking part in the processions. The sight of Alexei being carried by a bearded Cossack giant aroused sympathy and curiosity as to the nature of the Tsarevich's malady.

And then an incident took place on a bridge in the Bosnian capital of Sarajevo: an incident that was to alter the course of world history and trigger the fall of the Romanov dynasty. A group of Bosnian revolutionaries assassinated the Archduke Franz-Ferdinand, heir to the Austro-Hungarian Empire. World War I had begun.

The battle lines were drawn. When Austro-Hungaria occupied Belgrade, Russia rushed to the defence of the Slavs. At this, Germany hurried to support her ally, Austria. France joined Russia. The British sided with France.

It was a war for which Russia was ill equipped. The army under the command of Grand Duke Nikolai Nikolaevich was badly organized and short of munitions – the artillery ran out of shells within months. Russian losses were appalling. A year after the war had begun, about four million men had been lost.

At this point Rasputin began advising Nicholas, via Alexandra, about tactics, arousing the hostility of Nikolai

Nikolaevich, the Commander-in-Chief. To the horror of the Council of State, Alexandra persuaded Nicholas to sack Nikolai Nikolaevich. Nicholas took command of war operations personally, taking Alexei with him to the *Stavka*, the military headquarters. Alexei's presence was meant to raise morale, but while he was there he injured himself, and his father wore himself out by trying both to run the war and to stay up at night to nurse his son. Eventually, Nicholas had to send Alexei home.

The Tsarina and the Grand Duchesses, meanwhile, had thrown themselves into the war effort. Alexandra set up an evacuation centre in Tsarskoe Selo for 85 hospitals and had the Palace Hospital for injured officers built in the Imperial park. She and her two eldest daughters, the Grand Duchesses Olga and Tatiana, took their Red Cross certificates and nursed the wounded. It was gruelling, heartbreaking work. Anna Vyrubova said:

'Like all surgery nurses, the Tsarina handed over sterilised instruments, cotton wool and bandages, she took away the amputated limbs, dressed gangerous wounds.'

Alexandra did not think the Grand Duchesses Maria and Anastasia were old enough to be exposed to such horrors, so her two younger daughters simply visited the sick and performed small tasks on the wards.

While Nicholas was at the front, Alexandra became, in effect, the Regent of Russia. Under the sway of her 'Friend', Rasputin, who had worked so many 'miracles' with Alexei, she continued to send recommendations to Nicholas. In several cases, Nicholas heeded this advice, and ministers known to be unsympathetic towards the *starets* were replaced and permanently alienated. Dissent and dissatisfaction grew, and because Alexei's haemophilia was a state secret, no one understood why Alexandra remained under the spell of this uneducated *moujik* from Siberia. It was put down to fanatical religious feeling.

More obscene caricatures swirled around the capital. And then, in December 1916, Rasputin disappeared. Alexandra was frantic. She was well aware of her unpopularity and knew some people would stop at nothing to destroy her relationship with him. One attempt had already been made on the life of her 'Friend'. What had happened to him this time?

In Petrograd – St Petersburg had been renamed Petrograd in 1914 – the monarchists knew the tide was turning against them. Prince Felix Yusopov swung into action, inviting Rasputin to the fabulous Yusopov palace on the Moika Embankment. Here, under the guise of hospitality, the *starets* was given two glasses of wine and two cakes, which were meant to have been poisoned with potassium cyanide. These had no effect. Rasputin began to sing. Yusopov shot Rasputin in the back. Rasputin collapsed. Then he lurched to his feet and lunged at Yusopov. Recalling Rasputin's alleged supernatural powers, Yusopov turned tail and ran.

Rasputin made it into the courtyard. Again he was shot in the back. This time he fell for good. His assassins roped him up, made a hole in the ice of the Neva and dumped him in. Rasputin's corpse was not found for three days, and when it was, Alexandra was devastated. Thousands of others, however, rejoiced at Rasputin's death.

Prince Felix was banished from Petrograd, which probably saved his life, since he was one of the few members of the Imperial Family to survive the Revolution. But Rasputin's murder had been too little and too late to save the autocracy.

The Ekaterinburg Massacre

TWO MONTHS LATER an acute food and fuel shortage put most of Petrograd on strike. Attitudes were polarizing. Ministers telegraphed Nicholas, and the army – or that part of it not occupied at the front – was instructed to restore order. It mutinied, and many soldiers joined the revolutionaries. Red was the colour of the revolution; in Russian red originally meant 'beautiful'. Confidence was such that people wore red armbands and cockades. The city was aflutter with red ribbons.

Nicholas attempted to dissolve the Duma, but parliament refused to go, and, together with the Soviet, occupied the spacious Tauride Palace on the Neva. Russia teetered on the brink of civil war.

Virtually a prisoner in Tsarskoe Selo, Alexandra was coping with sickness in the family. Her children had measles, and when their hair started to fall out, their heads were shaved. In between nursing her children, Alexandra dashed off letters to Nicholas who was travelling the country on the Imperial train trying to keep control of his empire. After all their years together Nicholas and Alexandra still wrote to each other every day they were apart, 653 letters in all.

The Imperial train was halted at Pskov, where Nicholas was persuaded that the best way to avoid unnecessary bloodshed was to take the most important decision of his life and abdicate. In order not to be separated from his son, Nicholas abdicated in favour of his brother, the Grand Duke Mikhail. His last act as Tsar was to call on his army to support the Provisional Government. The reign of Tsar Nicholas II of Russia was over. In one letter written at this time, Alexandra complains that Nicholas had been 'caught like a mouse in a trap'.

Twenty-four hours later, Grand Duke Mikhail, having been told his safety could not be guaranteed if he took the crown, also abdicated. Over 300 years of Romanov rule had come to an end.

After his abdication, Nicholas Romanov hoped that the family would be allowed to retire to Livadia on the Crimea, but this remained a pipe-dream. The ex-Tsar was escorted to Tsarskoe Selo and put under house arrest with his wife and children. Initially, conditions were not harsh, and the family, though under guard, was permitted a degree of freedom. They rose at 8 am and had morning tea. They were allowed to walk for an hour before noon and for longer in the afternoons. During these exercise periods, the ex-Tsar could be seen dressed in the khaki of a common soldier in the park at Tsarskoe Selo. He shovelled snow to clear paths, the silver cross of St George flashing on his breast in the wintry sunlight. He cycled.

When spring came, and his children had recovered from the measles, Nicholas had them digging a kitchen garden, to help eke out their rations. Always one to relish physical exercise, Nicholas had a trapeze installed – a similar trapeze had been put up in the Imperial train for his use while travelling. In the evenings Nicholas read the classics to his family, while Alexandra and her daughters did needlework; played the piano; pasted photographs in their albums; or played bezique. Alexandra had aged terribly. Worn out with fretting about her son, she suffered

from a nervous condition and a weak heart. She spent much of her time in a wheelchair. There was talk of the family being allowed to go and stay with relatives in Europe.

Outside Tsarskoe Selo, news of the Revolution spread fast, and exiled Bolsheviks, Lenin among them, returned to Russia, putting to an end all possibility of the ex-Tsar and his family being allowed to leave the country. Instead the Romanov family were transferred to the Governor's house in Tobolsk, Siberia.

The family said farewell to most of their retainers at Tsarskoe Selo, but a few friends and servants came with them to Tobolsk. The family physician Dr Botkin stayed at their sides till the bitter end. The sailor Nagorny proved loyal, too, even though his colleague Derevenko abandoned the family. Nagorny wore himself to a shadow looking after Alexei when he was ill. The children had their tutors, among them Pierre Gilliard and the Englishman Gibbs. Lessons continued. They were allowed to take their dogs with them. Soon after their arrival Alexei's pet spaniel, Joy, was bitten by a snake, but she recovered. Joy was destined to be the sole survivor of the massacre at Ekaterinburg. Life at Tobolsk, though more restricted, was not unbearable.

The October Revolution of 1917 put the Bolsheviks in power. Conditions at Tobolsk deteriorated, and Citizen Romanov (Nicholas) was summoned to Moscow. Fearing that Nicholas would be killed, Alexandra refused to be separated from him. Alexei was seriously ill at the time, and she was torn between wishing to be with her husband and wanting to nurse her son. Alexandra chose to go with Nicholas. Her third daughter, Maria, went with them, on the understanding that the rest of the family would follow later.

The train carrying Nicholas, Alexandra and Maria was intercepted by the Ekaterinburg Communists (a radical group who refused to take orders from Moscow), and the three were escorted to a new prison in Ekaterinburg in the Ural Mountains. They were lodged in the requisitioned house of an engineer, Ipatiev. Three weeks later they were joined by the rest of the family, but Dr Derevenko and the children's tutors, Gibbs and Gilliard, were ordered from the area.

The régime in the Ipatiev House was designed to humiliate. The Tsar put up his trapeze, and when the guards saw his feet swing higher than the fence, they ordered a second fence to be built outside the first one. Every day conditions became harsher. Twenty minutes' exercise was reduced to five minutes. Physical jerks were banned. When Nagorny, Alexei's faithful sailor-companion, remonstrated with a Red Guard who had stolen a gold chain belonging to his charge, he was arrested, taken from the house, interrogated and shot.

Doors were removed from bedrooms and lavatories. Red Guards accompanied the girls everywhere. Obscenities were scrawled on the walls, and in the evenings Olga and Tatiana were forced to play crude songs celebrating the Revolution on the piano for the guards. The windows were whitewashed so that the family could no longer see out, and communication with the outside world was severely limited. Throughout Russia rationing had been introduced, and there was not enough food. On medical grounds, Dr Botkin obtained permission for extra milk and eggs to be delivered from a nearby convent for the sick Alexei.

The Ipatiev House was renamed the House of Special Purpose by the Bolshevik Cheka, the secret police, who

had their headquarters in Hotel America across the street. This group replaced the old guards and began planning the family's murder. One of their number, a man named Yurovsky, had already interviewed the Romanovs, posing as a doctor. The Cheka was under pressure to act because the White Army was approaching Ekaterinburg; they could not risk the ex-Tsar and his family falling into the hands of their supporters. Nor did they want the family to be turned into martyrs. They must destroy all evidence of the planned massacre. On 16 July 1918 coded orders were telegraphed from Lenin in Moscow. The murders were to be carried out immediately.

There was a last-minute delay because the trucks that were to remove the bodies were late arriving. Finally, in the early hours of 17 July, the trucks appeared.

The family and their remaining staff were woken and ordered to dress. With Dr Botkin, the cook, Nicholas's valet and Alexandra's maid, they were led into the basement. Alexandra was so weak she could barely stand. Chairs were brought for her and Alexei. Yurovsky marched in with a squad of twelve men and announced that, since attempts had been made by Nicholas's relatives to free them, the family's execution had been ordered.

Nicholas had no time to do more than exclaim when the shooting began. He died with the first shot. Alexandra and Dr Botkin also died quickly. The children and the maid, Anna Demidova, did not. Anna ran around the room screaming, while the bullets bounced off the girls and flew about. Blood spattered the cellar walls and pooled on the floor.

The victims' indignities did not end with their deaths. The bodies were taken to a mine shaft and stripped. Their clothing was burnt in an attempt to prevent identification by the approaching White Army, and at this point the assassins discovered the girls had sewn jewels into their corsets, which had then acted as flak jackets.

The naked bodies were buried in a shallow grave-pit under some railway sleepers. For decades the Bolsheviks denied having slaughtered the family, and the mystery surrounding their disappearance fascinated millions. The bodies lay undisturbed until the political climate in Russia eased enough for scientists to excavate the site. The remains were exhumed in 1991.

Since then DNA tests have been conducted by British Home Office forensic scientists, using samples given by the Duke of Edinburgh, who is a blood relative of Alexandra, and the descendants of Nicholas's grandmother. These prove conclusively that the bodies of Nicholas, Alexandra and three of their daughters lay in the grave-pit. Alexei and one daughter are missing.

In the 1960s the family's murderers made tape-recordings of their version of events in July 1918, in which they claimed to have burnt the two smaller bodies to cause confusion with identification should the grave ever be discovered. Despite considerable searches no trace of these bodies has ever been found.

In April 1992 the Patriarch of Moscow and the Orthodox Church Synod accepted the canonization of Alexandra's sister Ella. The canonization of other Romanov martyrs of the Russian Revolution, including the Tsar Nicholas and his family, has been left open.

May they rest in peace.

A CHRONICLE
IN PICTURES

An Imperial Inheritance

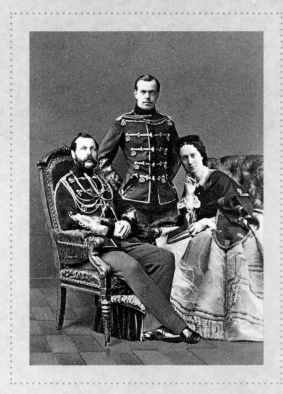

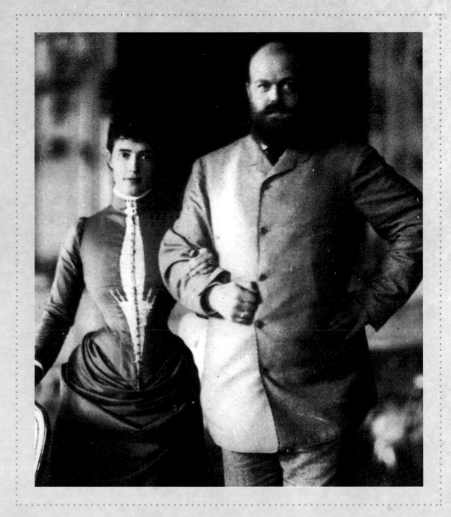

The Emperor of Russia, Alexander II (reg 1855–81), with Empress Maria Alexandrovna (both seated).

Behind them stands their son, the Grand Duke Alexander (reg 1881–94), who was Nicholas II's father. He became Tsar Alexander III when Alexander II was killed by a terrorist's bomb that shook the windows of the Winter Palace in St Petersburg. Legs shattered by the blast, the Tsar was carried in to die. His thirteen-year-old grandson, the future Tsar Nicholas II, witnessed his dying moments.

Tsar Nicholas's parents.

Maria Feodorovna (Princess Dagmar of Denmark) was originally engaged to marry Alexander's older brother, the Tsarevich Nikolai Alexandrovich. When Nikolai died of tuberculosis in 1865, Alexander not only became heir to the throne but also married Maria in his brother's place.

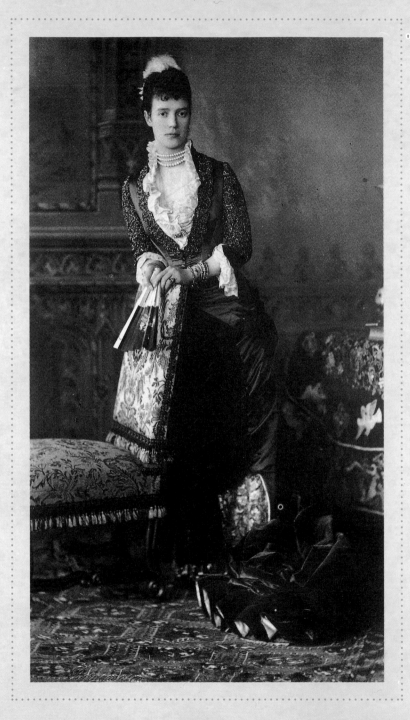

The Grand Duchess Maria Feodorovna.

Tsar Nicholas II's mother. Daughter of King Christian IX of Denmark, Maria won the hearts of the Russian people. She and Nicholas had a loving relationship, and, after he succeeded to the throne, Nicholas would often take his mother's advice. During the Russian Revolution Maria was rescued by a British battleship and so escaped the terror. She spent the rest of her life in her homeland of Denmark.

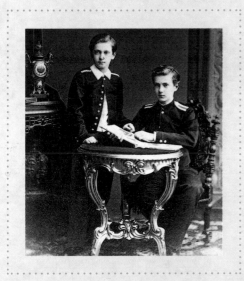

The Grand Dukes Sergei and Pavel as boys.

Grand Duke Sergei (seated) married Elizabeth of Hesse (Tsarina Alexandra's sister Ella). He was assassinated in 1905. Grand Duke Pavel was executed in 1919.

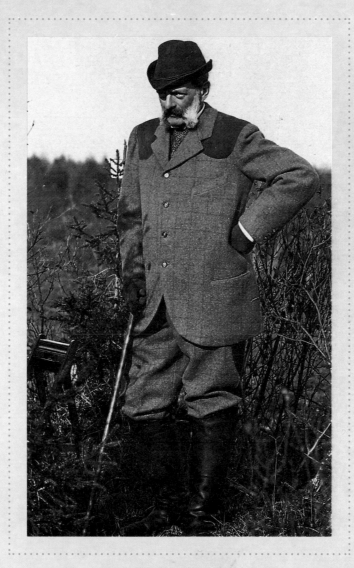

The Grand Duke Vladimir.

Grand Duke Vladimir's son Kirill caused a family rift by marrying Victoria Melita, the divorced wife of the Grand Duke Ernst of Hesse (Alexandra's brother). After the Revolution Kirill became Emperor in exile.

Grand Dukes Nikolai Nikolaevich (left) and Alexei Alexandrovich.

Grand Duke Nikolai was Supreme Commander-in-Chief of the Russian army at the beginning of World War I. Grand Duke Alexei Alexandrovich was a son of Alexander II.

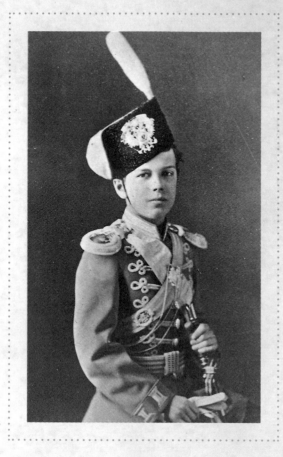

The Tsarevich Nicholas as a boy, c. 1881.

Tsarevich was the title given to the Tsar's eldest son and heir. A Tsar's other children were known as either Grand Duke or Grand Duchess. The title was held for two generations only, thus a third generation would be titled Prince or Princess. Here the future Nicholas II is wearing the uniform of the Ataman Cossack Guards.

The Tsarevich Nicholas in a Japanese rickshaw.

This was taken in Nagasaki in April 1891, moments before a Japanese policeman made an assassination attempt on Nicholas's life. A companion, Crown Prince George of Greece, saved him.

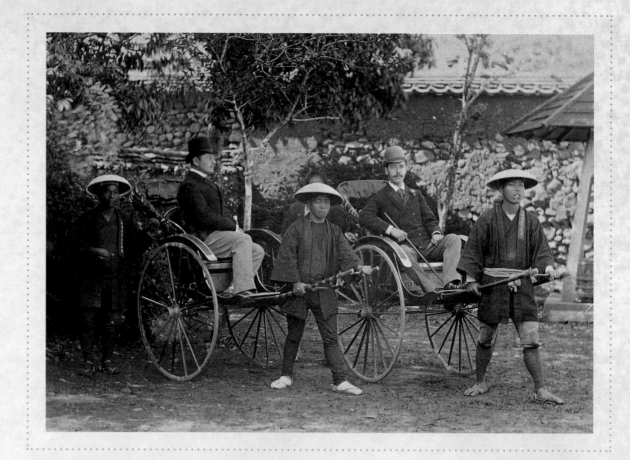

Princess Alix of Hesse, Nicholas II's chosen bride.

Alix (later Tsarina Alexandra) as a young woman. Alix visited
Russia for the first time in 1884, when she attended the wedding of her
sister Ella to Nicholas's uncle, the Grand Duke Sergei

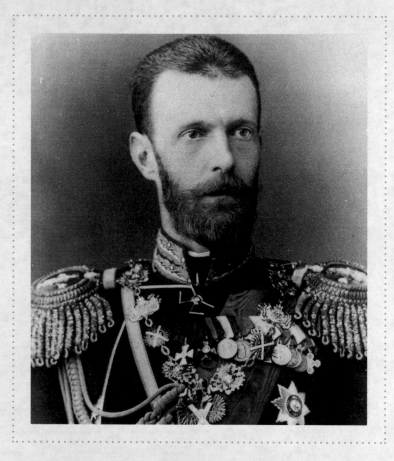

Alexandra's sister 'Ella'.

The Grand Duke Sergei.

Elizabeth (Elizabeta Feodorovna) married Grand Duke Sergei (Sergei Alexandrovich) who was murdered in 1905. Deeply religious, Ella took the veil after her husband's death, but her habit did not save her when the Revolution came. She was murdered the same night the Tsar's family died in 1918. As part of the Bolsheviks' purge, Ella was rounded up with other members of the Romanov family and flung alive down a mineshaft near Alapaevsk in the Urals.

An uncle of Nicholas II, as well as his friend and adviser, Sergei Alexandrovich was killed by a bomb while riding in his carriage through Senate Square in the Kremlin. When a frantic Ella ran out to her husband all she could find of him was one hand and part of a foot. Sergei's head was never found.

A Growing Family

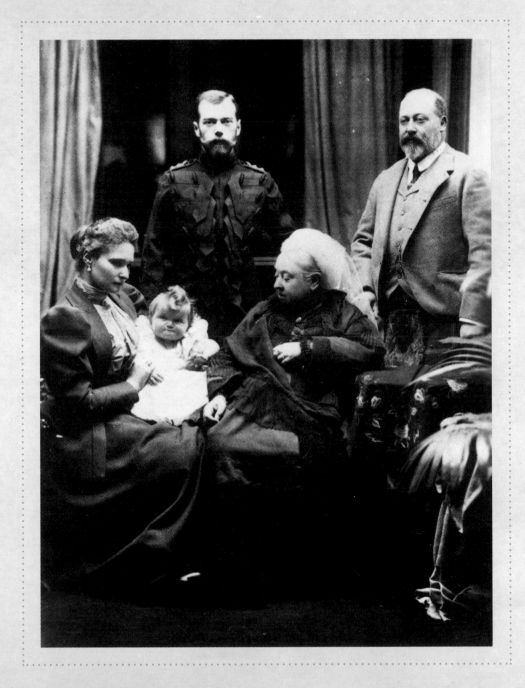

The Tsar, the Tsarina and their firstborn with Queen Victoria and the future King Edward VII, at Balmoral in 1896.

Nicholas and Alexandra married in 1894. Alexandra was Queen Victoria's favourite grandchild. Here Alexandra shows her firstborn, the Grand Duchess Olga, to her grandmother and her Uncle Edward.

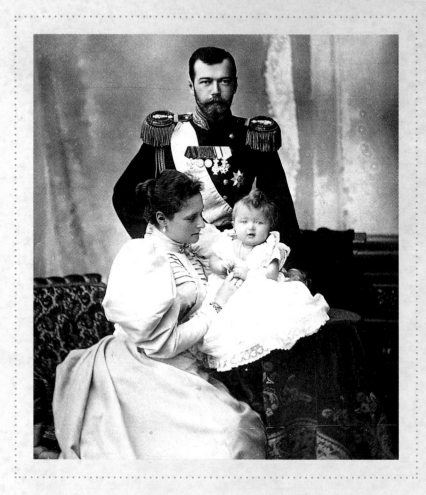

Nicholas and Alexandra in 1886, c. the time of their Coronation.

The Imperial couple pose for a formal photograph with their firstborn, the Grand Duchess Olga. The whole family were keen photographers. They enjoyed posing and taking photographs, and left a rich pictorial legacy.

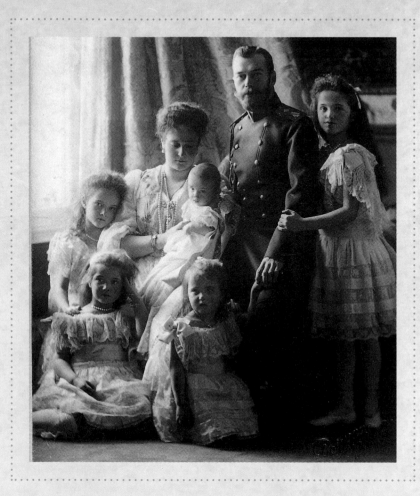

The birth of an heir.

Nicholas and Alexandra had four daughters: The Grand Duchesses Olga, Tatiana, Maria and Anastasia. According to Russian law, daughters could not succeed to the throne. Alexei's birth in 1904 was therefore greeted with great rejoicing. Here the family pose when Alexei is about six months old. Alexandra's smile as she looks at her son hides a tragic secret. Alexei suffered from a disease that was then incurable – haemophilia. Queen Victoria was a carrier of haemophilia. She had passed the disease on to her daughter Alice, who in her turn had passed it on to Alexandra

(SEE FAMILY TREE).

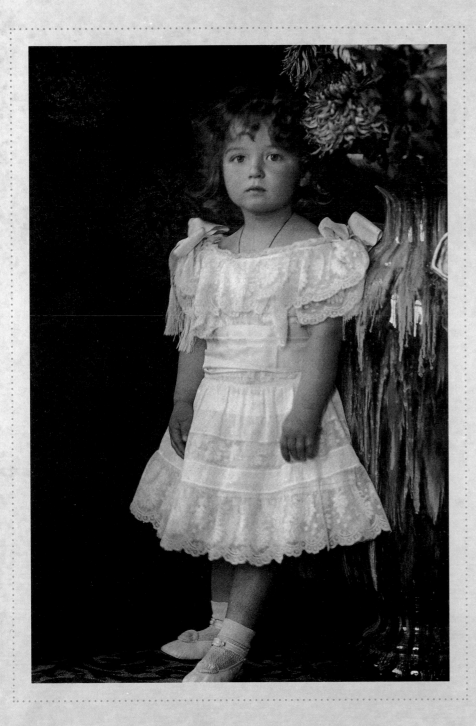

The Grand Duchess Anastasia as a toddler.

Anastasia is wearing a *kokoshnik*, a type of Russian crown fashioned from velvet and embroidered with pearls.

· B E L O W ·

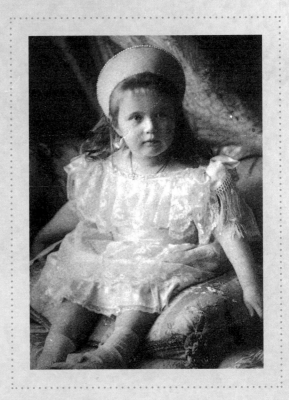

The Tsarevich Alexei.

As was customary at the time the little boy has long hair, which has been allowed to curl naturally. His dress and shoes are identical to those his sister Anastasia wore when she was a toddler. This photograph gives no hint of Alexei's haemophilia, which cast a shadow over his life and the lives of his family. Alexandra never forgave herself for passing the disease on to her son. For political reasons, the family decided to keep Alexei's illness a secret. The strain involved in keeping this secret, and of constantly worrying about her son, eventually took its toll on Alexandra's own health.

The Four Grand Duchesses and the Tsarevich on the Imperial yacht in 1906.

Alexandra's mother, Princess Alice, died when Alexandra was six. Thereafter, Alexandra spent much time in England at the court of her grandmother, Queen Victoria. As children, Alexandra and her sisters were often dressed in similar costumes. Alexandra continued this tradition with her children.

· R I G H T ·

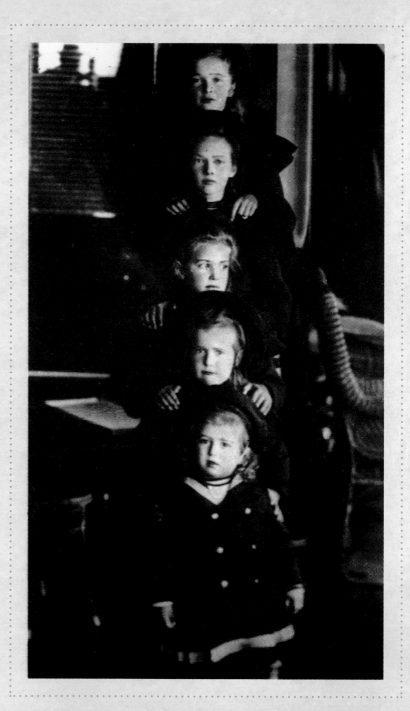

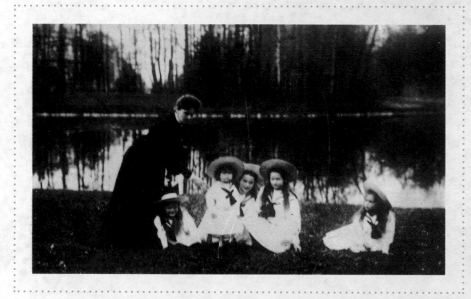

The Tsarina Alexandra with her children in 1906.

One of the Imperial Family's favourite residences was at Tsarskoe Selo, a few miles outside of St Petersburg. Here Alexandra keeps an eye on her children by the lake in the palace park. The children are dressed uniformly, and once again little Alexei is wearing skirts.

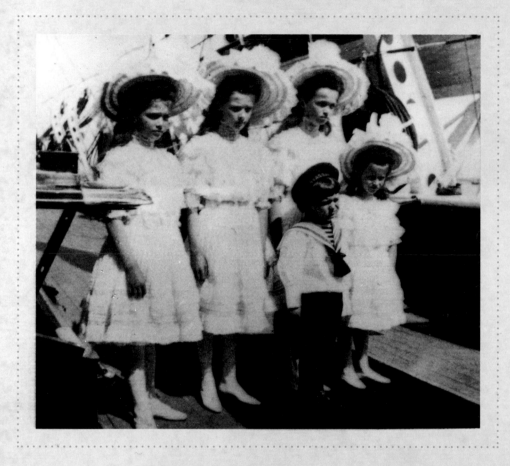

The Imperial children on the Imperial yacht.

On the back row (left to right) are Maria, Tatiana and Olga. Alexei and Anastasia are standing in front of them. Once again the girls dress uniformly, but Alexei is now old enough to have a boy's haircut and wear a sailor suit.

Alexandra with her daughters.

(Left to right) the Grand Duchesses Maria and Olga, the Tsarina Alexandra and the Grand Duchesses Tatiana and Anastasia.

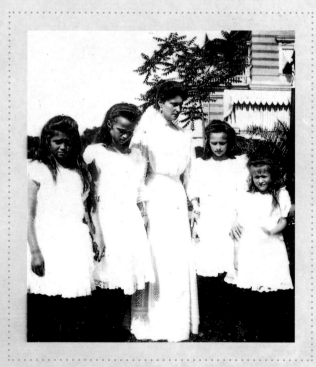

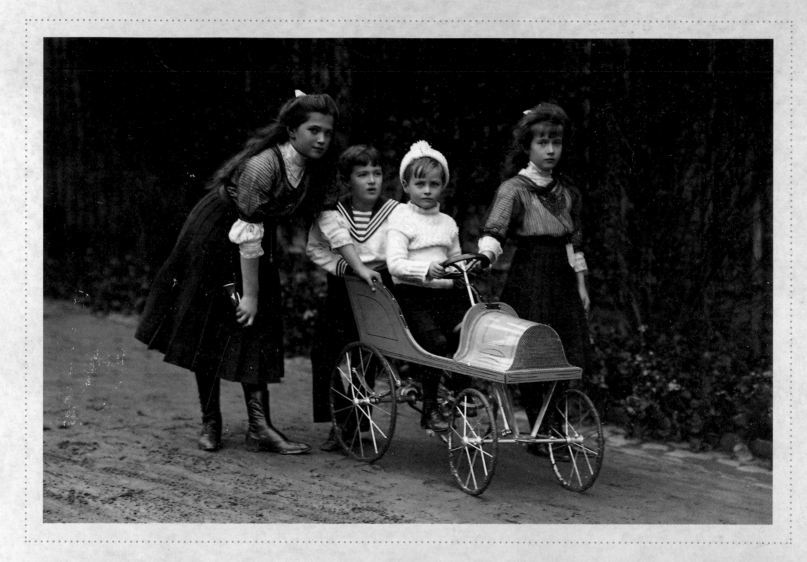

At a hunting-lodge in the German Grand Duchy of Hesse, 1910.

Maria and Alexei push cousin Georg Donatus of Hesse in a toy car. Anastasia steers. Maria is holding a toy horn.

An outing.

Alexei stands at the back (right). Derevenko, one of the two sailors who acted as Alexei's nanny/guardian, waits to give his charge a ride on his bicycle seat. Later, when the tide turned against the Imperial Family, Derevenko was to abandon Alexei.

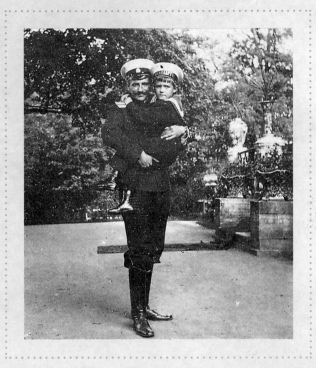

Alexei often had to be carried.

Alexei's childhood was shadowed by his illness, and at times he had to be handled more carefully than the most delicate Venetian glass. An insignificant playground tumble could cause painful internal haemorrhaging and kill him. It was not easy to find the right balance between protecting the Tsarevich from the effects of his haemophilia and allowing him to play like a normal child. He would often ask why he could not be like other boys.

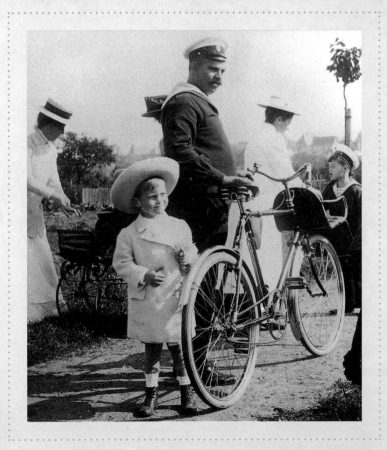

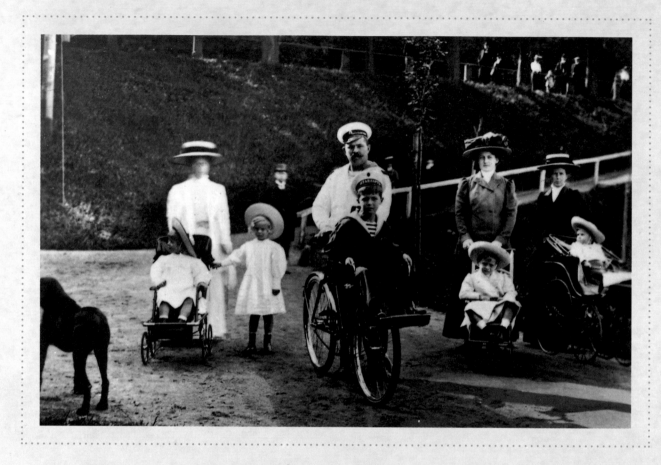

Alexei and his cousins.

Hereditary Grand Duke Georg and Prince Ludwig of Hesse, the two sons of Ernst, Grand Duke of Hesse,
who was Alexandra's brother are on the right. In the centre Alexei is in his bicycle seat being pushed by Derevenko, while
on the left are the two Princesses of Greece. The Imperial Family were very fond of animals – note the dog
in the foreground on the left.

Constant care.

Alexei was never left alone for a moment in case he fell and injured himself. Here he plays with a cousin under the watchful gaze of Derevenko, his sailor/companion.

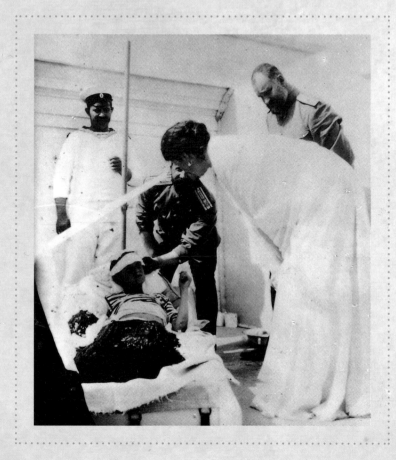

Alexei takes a mud bath.

After a fall, Dr Derevenko (no relation to the sailor, centre) prescribes a mud bath to ease the pain in Alexei's joints. Dr Derevenko explains the treatment to the Tsarina. Another family physician, Dr Botkin (right), and the sailor Derevenko (left) listen. The physician Dr Botkin remained with the Imperial Family after they were imprisoned in 1917. He paid for his loyalty with his life – he was shot alongside them at the Ipatiev House, Ekaterinburg, in July 1918.

A tutors' meeting in Livadia in the Crimea.

The tutors met on the terrace at the family's holiday palace in 1913.
(Left to right) Pierre Gilliard; Father Alexander Vasiliev, the Tsar's confessor
and the children's religious instructor; Petrov, the Russian professor; and
Catherine Schneider, the German tutor who taught the engaged Alexandra
Russian. Schneider was arrested when the family were taken to Ekaterinburg
by the Bolsheviks and later sentenced to death.

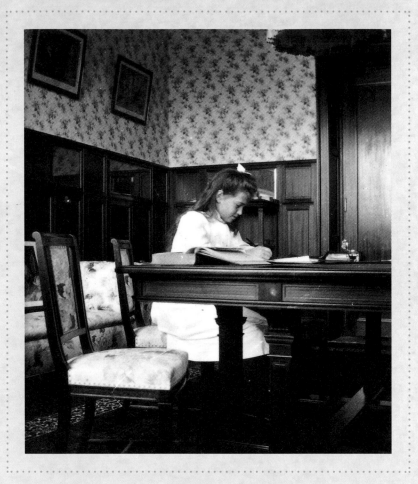

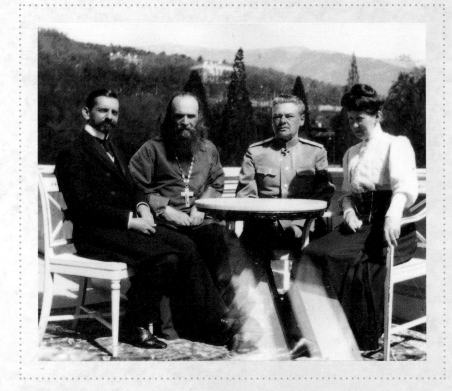

Anastasia studying.

Anastasia was the scamp of the family, always clowning around.
This photograph has captured her in a rare, studious mood.

At Play

Hunting at Spala, October 1912.

Nicholas's bag after a hunt in Poland. Nicholas's Empire was vast and took in one-sixth of the earth's surface. It included Poland and Finland in the north-west, where the Imperial Family liked to spend holidays.

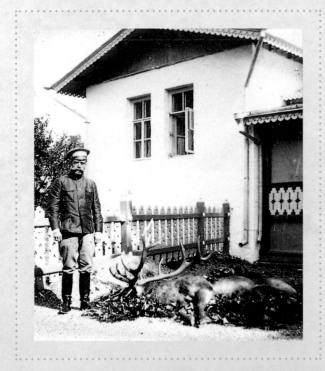

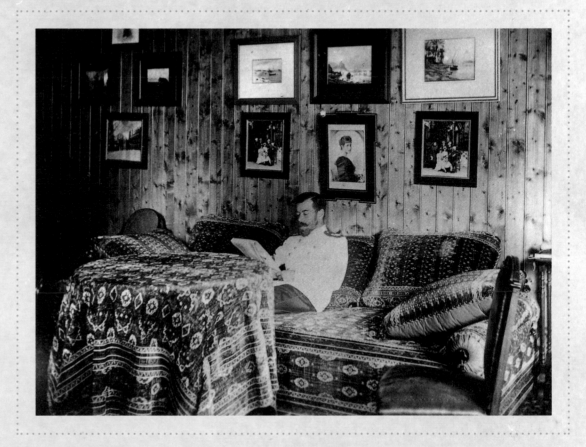

The young and untried Tsar Nicholas.

Nicholas relaxing shortly after ascending the throne. Stunned by his father's unexpected death, Nicholas confessed to being unready and unwilling to take up the reins of government. Note the family portraits and watercolours on the walls and the Oriental textiles on both sofa and table.

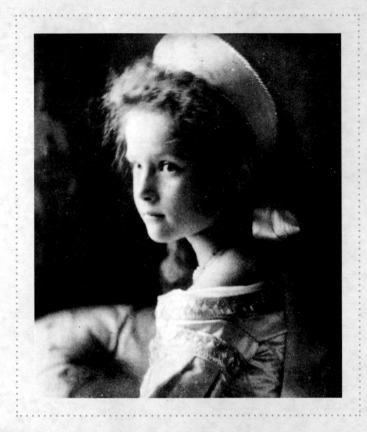

The Grand Duchess Anastasia.

Anastasia enjoyed dressing up. This is an informal picture
of her in court dress wearing a *kokoshnik*.

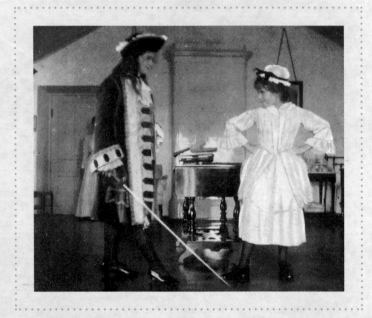

Maria (left) and Anastasia play-acting in 1912.

The children enjoyed amateur dramatics. This is a production of
Le Bourgeois Gentilhomme.

Nicholas was a chain-smoker.

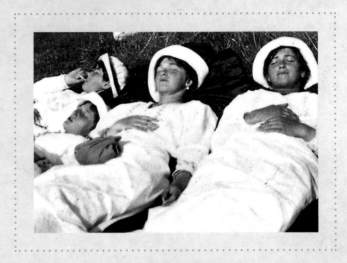

Like father, like daughter.

Close examination of this photograph shows Anastasia (top left)
pretending to smoke with a rolled-up piece of paper.

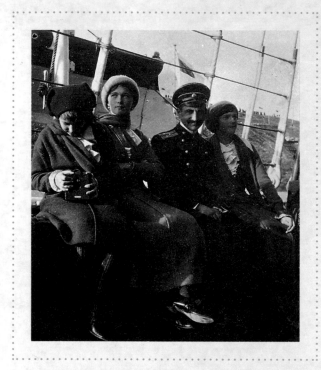

Three of the Grand Duchesses with their French tutor, Pierre Gilliard.

On the Imperial yacht. Anastasia (left) is taking a picture of the photographer with her box camera. Seated next to Anastasia is Olga, and on Gilliard's left is Tatiana. Maria could be the photographer whose picture is being taken.

Grand Duchesses Tatiana (centre left) and Olga.

Here with their cousin Princess Irina Alexandrovna. Later Irina was to marry Prince Felix Yusopov, the man who was to plot and carry out Rasputin's murder.

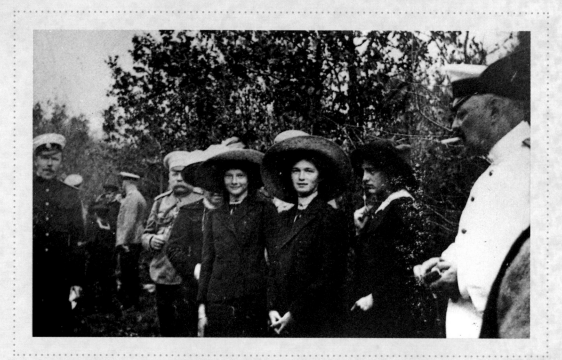

A shopping expedition for the Grand Duchesses in Germany. Like Alexandra, Wilhelm II (the Kaiser) was a grandchild of Queen Victoria, and the family were on visiting terms until World War I. Alexandra's links with Germany – she was known derisively as 'the German Princess' – made her an easy target for distrust and dislike.

·LEFT·

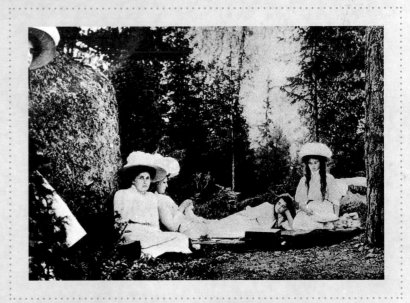

Relaxing at a picnic in Finland.

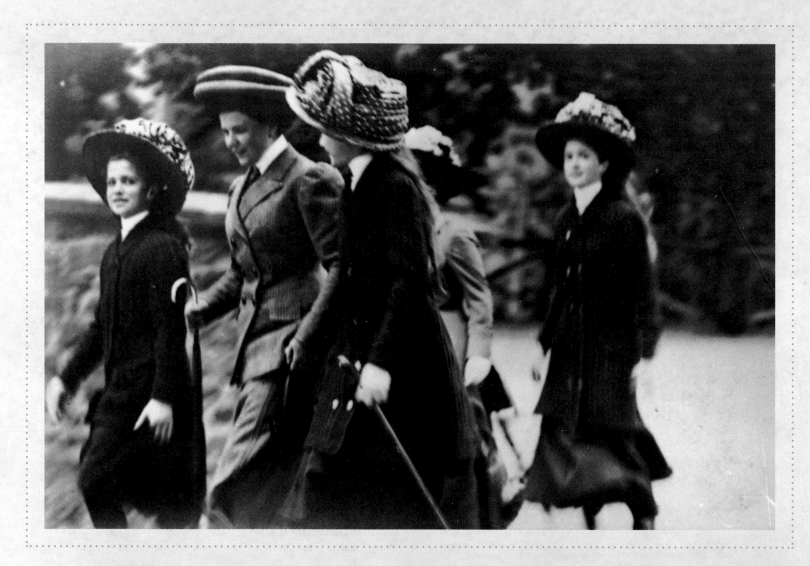

Out for a walk.

The Grand Duchesses stride out. Though older, the girls still wear matching outfits.

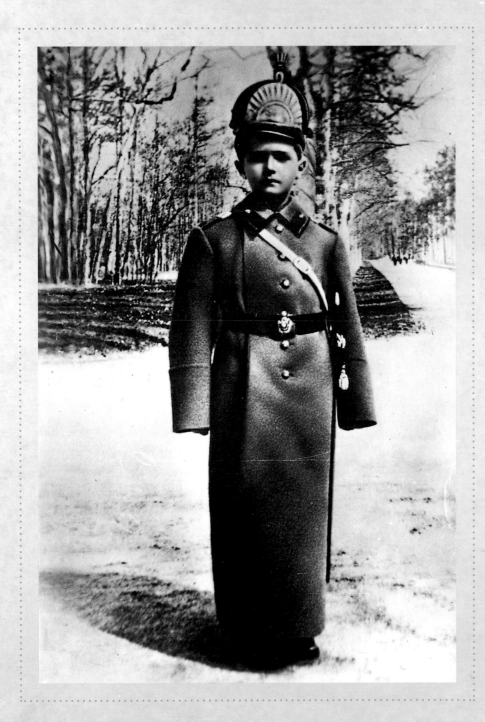

Alexei in a uniform that gives room for growth. By tradition the family maintained close links with the armed forces, and both Alexei and Nicholas liked to wear uniforms.

·LEFT·

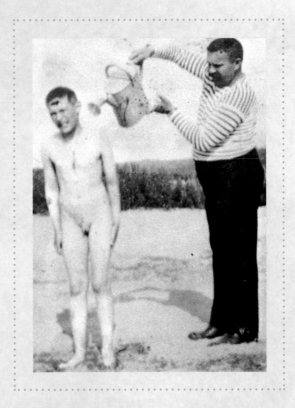

The Tsarevich in summer.

Derevenko rinses off Alexei after a swim.

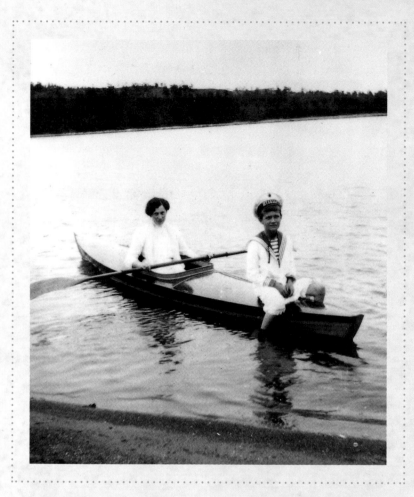

Tegleva, the children's nurse, canoes for Alexei.

Tegleva was married to the French tutor, Pierre Gilliard. She and her husband escaped to Switzerland after the Revolution.

Alexei by an Imperial train.

Russia had a rural peasant economy, but during Nicholas's reign the Empire gradually became more industrialized. The Trans–Siberian Railway forged links across the Russian Empire as far as its eastern borders at Vladivostok on the coast of the Sea of Japan. Trains were relatively new to Russia and incorporated the latest in steam technology. Alexei was not the first nor the last little boy to be fascinated by them.

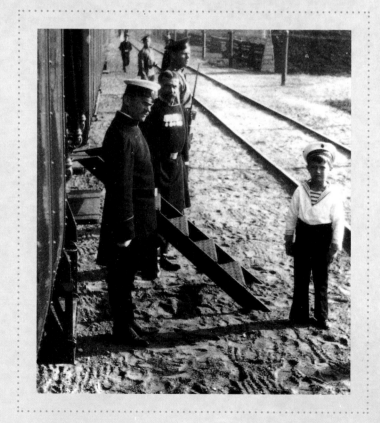

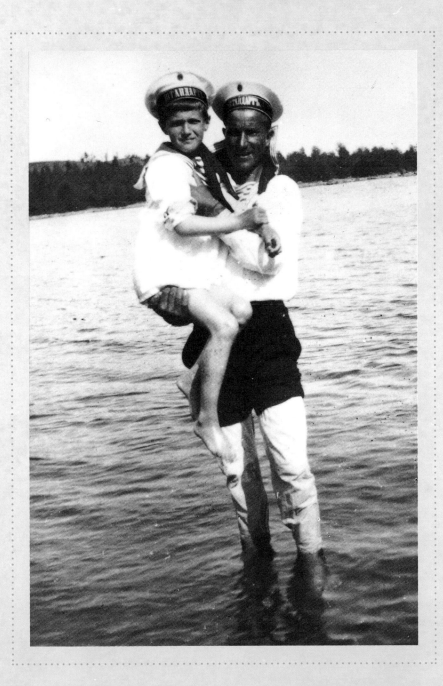

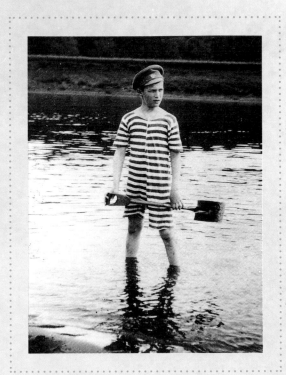

Alexei and Nagorny.

Alexei being carried by Nagorny, his other sailor/companion. Nagorny stayed faithful to the family and was shot in the Revolution. Both Nagorny and Alexei are wearing caps emblazoned with the name of the best-equipped of the Imperial yachts, the ultra-modern *Standart*.

· L E F T ·

The Tsarevich paddling.

Alexei takes a break from building sand-castles on the bank of the Dneiper near Mogilev, where Nicholas set up his headquarters, or Stavka, at the beginning of World War I. Nicholas took the Tsarevich with him in order to raise morale among his troops, but Alexei had to return to his mother after a fall, when he became seriously ill.

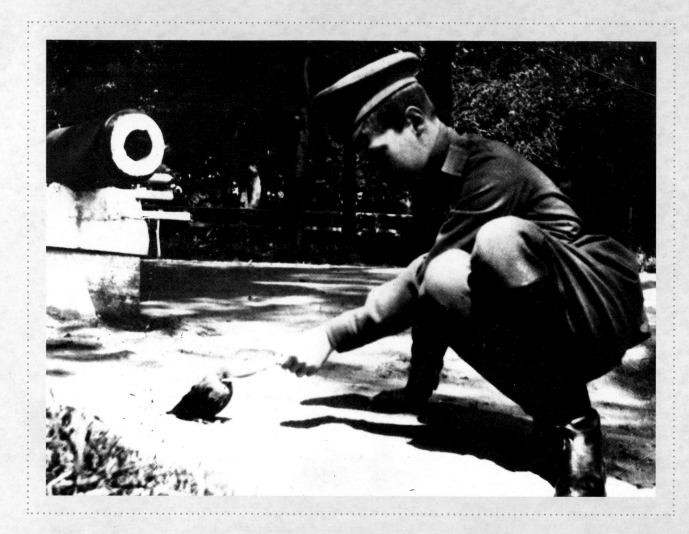

Alexei feeding a tame starling.

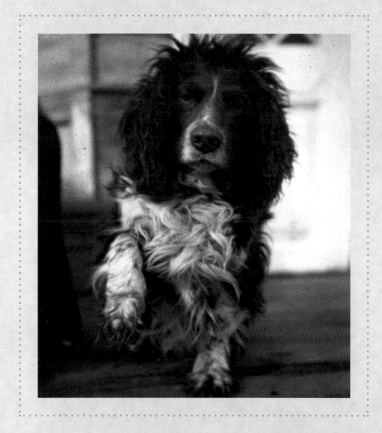 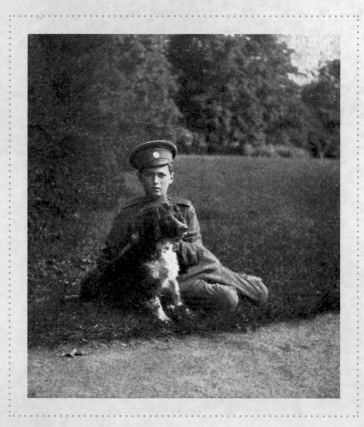

Alexei and his spaniel, Joy, in 1915.

After the Revolution, the Imperial Family took several pets with them into captivity. Joy is the only one known to have survived the 1918 massacre and was found frightened and half starved by the White Army when they took Ekaterinburg. Joy was later buried at Windsor Castle.

Alexei and his pony.

Wearing only his sailor's cap from the *Standart* as protection, Alexei sits bareback on his pony. Given the gravity of his illness, the Tsarevich was sometimes allowed to take part in potentially dangerous activities.

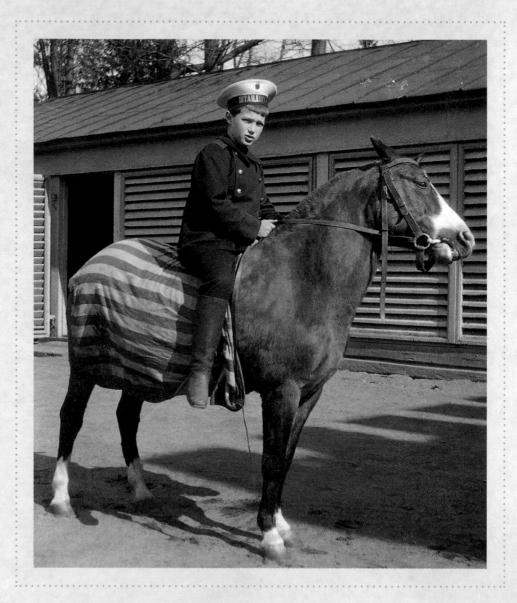

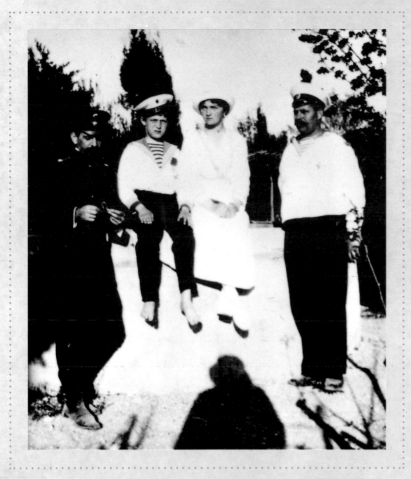

Olga and her barefoot brother.

In this photograph, Olga and Alexei are flanked by tutor Pierre Gilliard and the sailor Derevenko. The photographer's shadow is visible in the foreground. All the children enjoyed taking pictures, and the photographer may be Anastasia.

Out walking with officers, the Tsar pauses, anxious for his son.

Prince Igor Constantinovich who died in the mineshaft with Alexandra's sister Ella is on the extreme right. Pierre Gilliard, Alexei's French tutor, stands on the left.

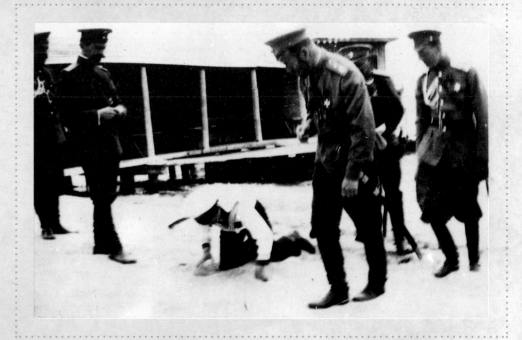

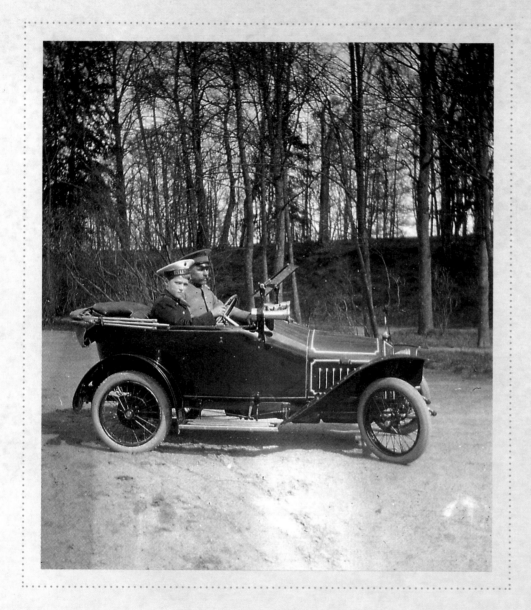

Alexei in the driving seat.

For a year, *c.* 1912, Alexei was in too much pain to walk. He had to be carried or driven everywhere.

Mushroom-picking in Finland.

Anastasia sits in the foreground.

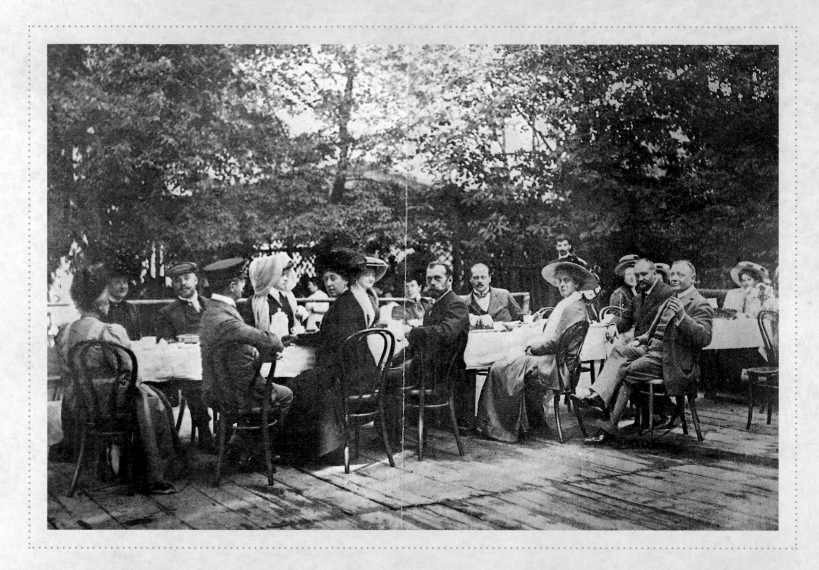

A coffee party at Münzenberg in the Duchy of Hesse, 1910.

Tsar Nicholas (centre) visiting his brother-in-law, Ernst, Grand Duke of Hesse.
Ernst is immediately to the right of Nicholas, on the other side of the table.

The Grand Duchess Anastasia, in her mother's bedroom.

The furniture in this room in the Alexander Palace is French, and the wallpaper matches the upholstery fabric. The Tsarina was extremely devout. She hung more than 800 icons in her bedroom and prayed night and day for a miracle to cure her son.

The Tsarina Alexandra in her carriage.

Towards the end of her life, Alexandra had a heart condition that worsened, causing her to spend time in a wheelchair. The Grand Duchess Anastasia stands in the centre, while her mother chats to her best friend, Anna Vyrubova. Known as the 'the Cow', Anna introduced Rasputin to the Tsarina. Wild and lewd rumours circulated concerning both her and Rasputin's relationship with Alexandra.

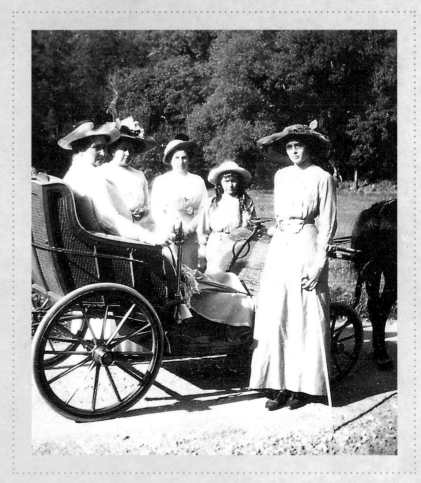

The Grand Duchesses Maria (left) and Olga.

The Grand Duchess Olga dressed more informally.

The hat indicates she is going for a walk.

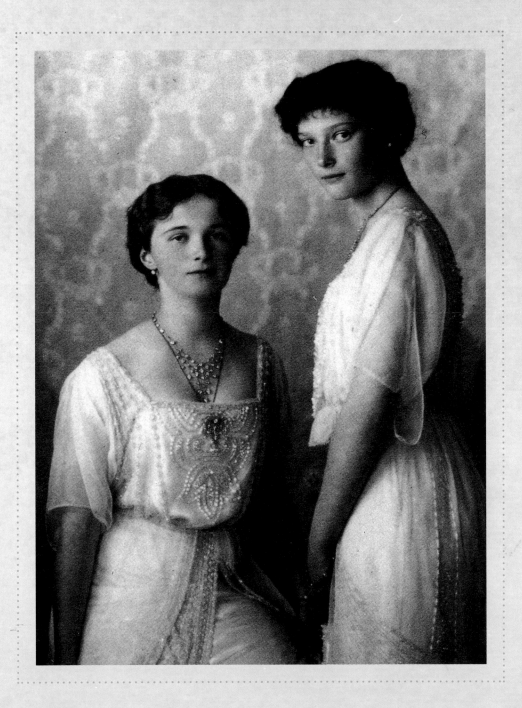

Photographic Portraits

The Grand Duchesses Olga (seated) and Tatiana.

The Imperial Family posed for many official portraits as well as for each other's private family albums. When the girls reached sixteen they were deemed old enough to put their hair up.

The Grand Duchesses Anastasia and Maria.

The two younger daughters are not old enough to put up their hair. Alexandra gave her daughters one pearl and one diamond every birthday, so that when they turned sixteen they could each have a necklace and brooch made up. All the girls attained that age, but Alexei was only thirteen when he was killed.

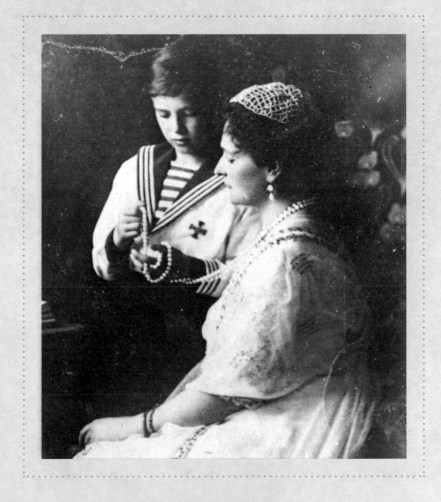

Mother and son.

A charming portrait showing the strong bond of affection between Alexandra and Alexei.

Tsar Nicholas carrying his son.

Nicholas is wearing an infantryman's khaki. He would not give his approval to a new uniform for his men until he had tested the kit personally. He ordered a uniform in his size, put it on and disappeared on a 25-mile route march. When Nicholas returned he pronounced the uniform satisfactory.

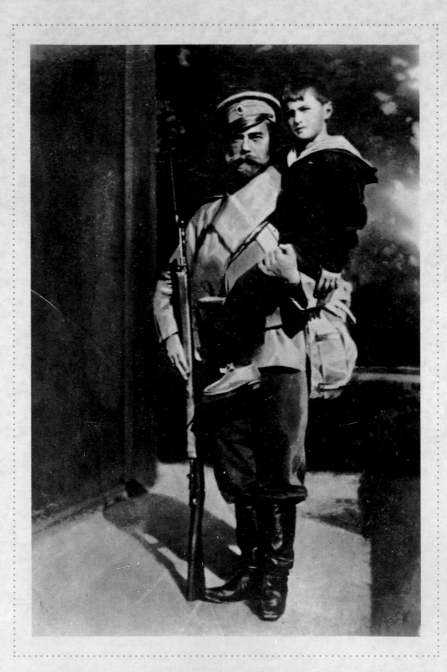

The Tsarina Alexandra.

A portrait of Alexandra in her state finery, by a vase of ferns and lilies. Alexandra loved flowers, one of her favourites being lilac. In the winter, when fresh fruit and flowers were out of season in St Petersburg, Alexandra would order hundreds of flowers and a variety of exotic fruits to be brought in by train from the Imperial palaces of the Crimea in the south.

Anna Vyrubova in court dress.

Traditionally court dress was made from garnet-coloured velvet, richly embroidered with gold and silver thread. Here Anna wears the *kokoshnik* with a long adult's veil. On her left shoulder is pinned a diamond brooch, bearing the initial of the family member whom she serves, in this case Alexandra.

Count Vladimir Fredericks.

The Minister of the Court in traditional costume. A much loved member of the court, Count Fredericks spent much time with the family, calling Nicholas and Alexandra 'mes enfants'. His house was burnt down in the Revolution.

Grigori Efimovich, known as 'Rasputin'.

Rasputin, which means dissolute, in his home village of Pokrovskoe
before his involvement with the Imperial Family. Like most Russian Peasants,
or moujiks, he was virtually illiterate. It is a tribute to his will-power and
intelligence that he came to exert such an influence over the Tsarina, who believed
that Rasputin had on several occasions saved the life of her son Alexei.

· L E F T ·

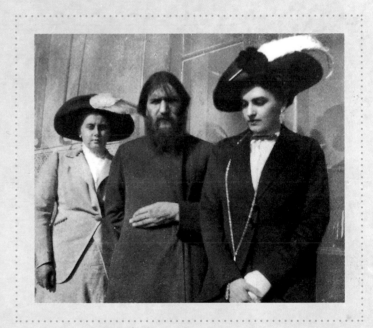

Rasputin with Anna Vyrubova (left) and the Tsar's niece, Princess Irina Alexandrovna.

As the Tsarina became increasingly desperate to find a cure for her son,
her religious fervour grew and so did Rasputin's influence. Rasputin was finally
murdered by Irina's husband, Prince Felix Yusopov, who was concerned about
the Tsarina's growing unpopularity and the rumours of her supposed sexual
relationship with Rasputin and Anna Vryubova. Rasputin was not easy to kill.
A first attempt failed completely. So Yusopov invited him to his home, where
he gave him poisoned wine and cakes. Still he lived. He was shot twice.
Finally he was flung into the frozen River Neva.

Ceremonial and Processions

A Grand Duchess tree-planting.

Tsarevich Alexei on parade.

Tsar Nicholas and Tsarina Alexandra process arm in arm with their son and heir alongside. This was possibly taken in 1913, during the Tercentenary Celebrations, although most photographs celebrating the 300-year rule of the Romanovs show Alexei being carried by a giant of a Cossack.

· A B O V E ·

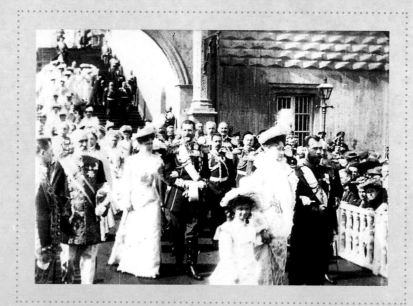

Parading past the Faceted Palace.

The Kremlin, Moscow, in 1903. The original Kremlin fortress was built in 1156 and was little more than a wooden stockade, which was repeatedly sacked by the Tartars. It has been the seat of both ecclesiastical and temporal power since ancient times. In 1718 the Russian capital was transferred to St Petersburg, but Russian monarchs still used the Kremlin on state occasions. Nicholas II was crowned there. Some 47 tsars are buried there. A whole floor of the Faceted Palace is taken up by a vast, vaulted throne-room with a single central pillar.

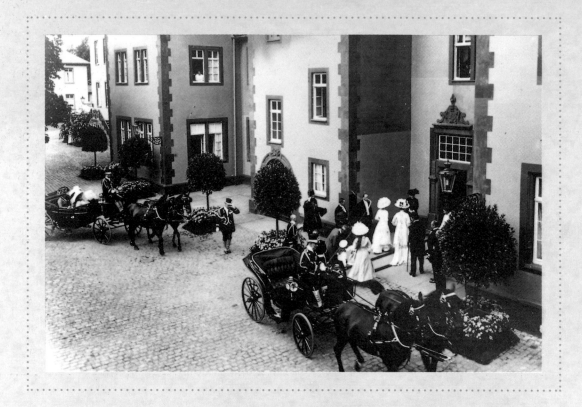

Visiting Hesse.

The Imperial Family arriving by
carriage at Friedberg in the Grand Duchy
of Hesse, Germany.

· A B O V E ·

The Day of the White Flowers.

Yalta *c.* 1912. The Tsarina and Alexei
collect funds for hospitals in the Crimea.
Olga and Tatiana hold garlands of flowers
behind the carriage. Everyone who
donates to the cause is given a
white flower.

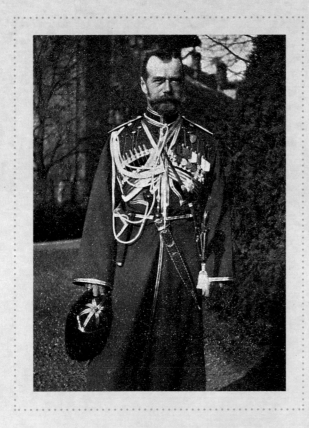

Tsar Nicholas, 1912.

Nicholas in the distinctive uniform of the Ataman Cossack Guards. The following four photographs come from Alexandra's album.

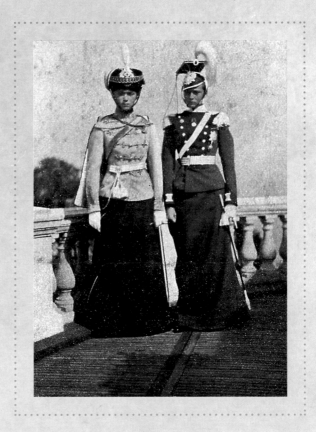

Honorary colonels-in-chief.

Nicholas believed his family had a role to play as figureheads for his army. Grand Duchess Olga (left) was honorary colonel-in-chief of the 3rd Hussars and wears their white dress uniform with silver and gold trimmings. Grand Duchess Tatiana's regiment was the 8th Uhlan Lancers, so her tunic is scarlet. Alexandra was patron of the Uhlan Lifeguards and Maria of the 9th Dragoon Kazansky regiment.

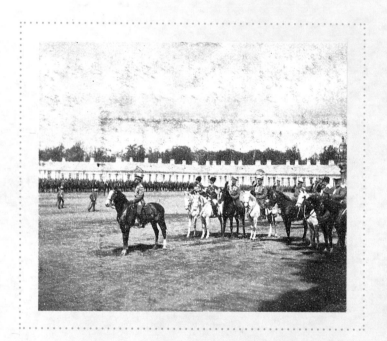 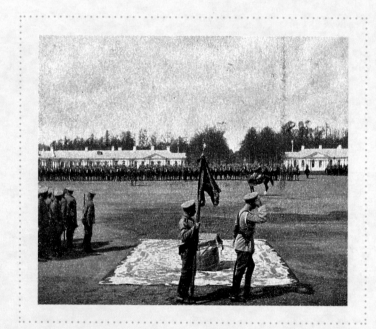

Manoeuvres and military review.

The guards' summer camp at Krasnoe Selo, 1915, during the course of World War I.

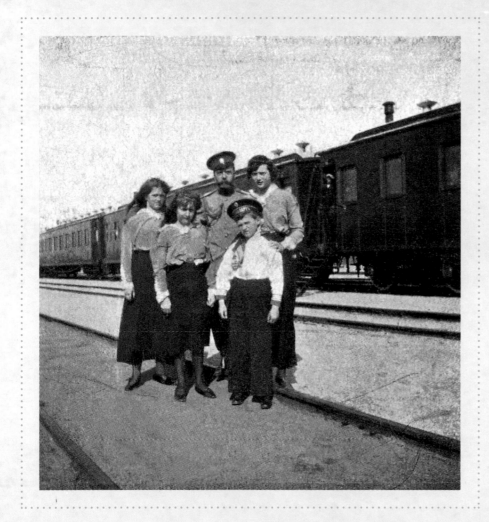

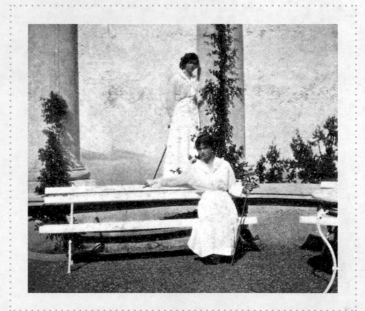

Preparing to board an Imperial train, 1914.

There were five Imperial trains. Nicholas and four of his children stand on the tracks, waiting to board one of them. This picture was probably taken by the fourth Grand Duchess. On the edge of the Black Sea, the Crimea has a Mediterranean climate and was the family's favourite holiday spot.

Oreanda, the Crimea, 1914.

Two of the Grand Duchesses take a breather after a walk. They wear hats and carry walking-sticks. Both these pictures are from the Tsarina's album.

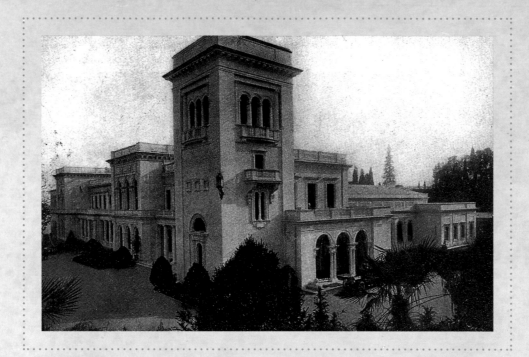

The Italianate Palace at Livadia.

The Imperial Family had seven palaces.
Nicholas had this one built for them, and it
was completed in 1911. It became their
most loved retreat.

·ABOVE·

A courtyard in the new palace.

This photograph is from the Tsarina's album.

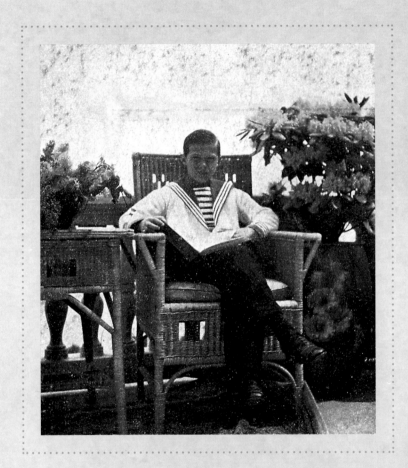

Alexei reading and posing for a photograph on a terrace of the new palace.

The following nine photographs are also from Alexandra's photograph album.

Livadia, 1913.

Olga and Tatiana reading and embroidering on the balcony. The Tsarina was an accomplished needlewoman, and she ensured her daughters were taught the traditional feminine skills. Tatiana loved embroidering. She also painted and drew well, a talent she inherited from both her parents who painted when they could.

Olga in the grounds of the palace at Livadia.

The Tsar's eldest daughter relaxes against a bank of irises, 1914.

The Grand Duchess Maria in 1914.

The palace at Livadia was built in white limestone on the edge of a cliff overlooking the Black Sea. Its gardens were dotted with Greek marbles of great antiquity, which had been dug up from Crimean ruins. Here Maria is sitting by an ornamental pond.

Gathering daisies, 1914.

The Grand Duchess Maria, aged thirteen.

The Grand Duchess Tatiana,
again in 1914.

Nicholas out walking in 1914.

An outdoor man, Nicholas insisted all his family should take
a daily walk. Here he pauses to be photographed with Anastasia
in the background.

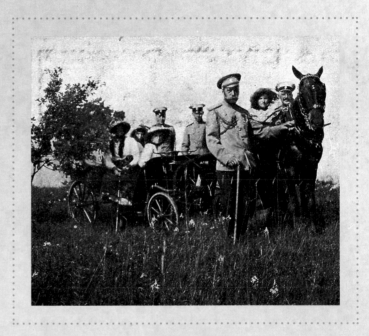

The Grand Duchesses in a pony and trap.

Nicholas leads the way. The family enjoyed picnicking in
the warm climate of the Crimea, and they had several pets that they
liked to take with them. The Grand Duchess on the extreme left is
holding a lap dog, possible Jemmy, who perished with the family in
1918 in the Ekaterinburg massacre.

The Tsarevich in the Crimea.

With Alexei are (left to right): Dr Vladimir Derevenko, the family surgeon who attended the heir to the throne, Dr Sergei Feodorov and tutor Pierre Gilliard.

·RIGHT·

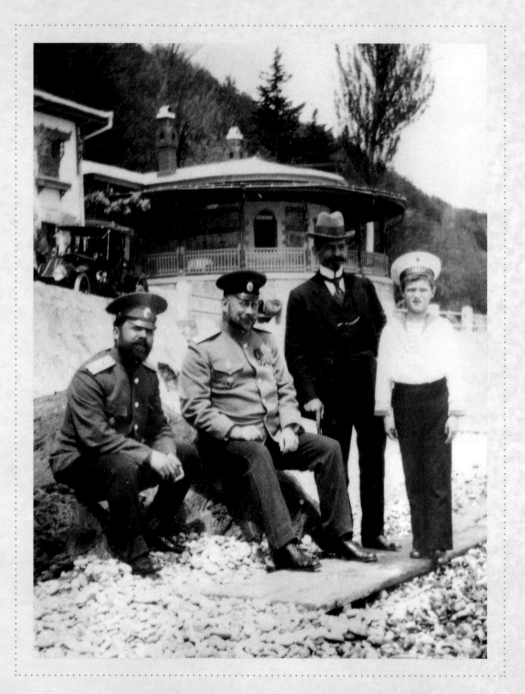

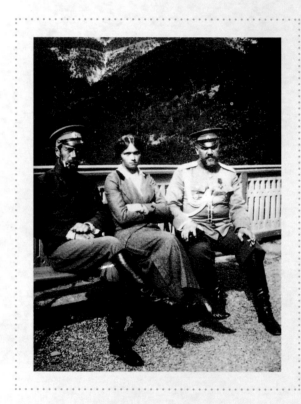

A chat with the doctor.

Nicholas and his firstborn, Olga, talk to Dr Eugene Botkin on the terrace of the palace.

Lessons on the terrace.

The French tutor, Pierre Gilliard,
with Maria and Tatiana. Nicholas
and Alexandra's children were taught
several languages besides Russian.
They spoke English, French
and German.

The Romanovs' Retreat

Federovsky Gorodok, Tsarskoe Selo, 1913.

Fifteen miles south of St Petersburg, set in an Imperial park cut off from the rest of the world, was 'the Tsar's village'. Tsarskoe Selo Park was encircled by a high iron fence and guarded round the clock by scarlet-coated Cossacks with gleaming sabres. Entry was restricted to a few of the family's closest friends. A succession of Tsars had palaces built at Tsarskoe Selo, among winding paths and sweet-smelling shrubs, including the lilac the Tsarina loved. There was even an artificial lake. Nicholas's family preferred the smaller, more private Alexander Palace at Tsarskoe Selo to the formal grandeur of the Winter Palace in St Petersburg. This picture and the following one are from Grand Duchess Maria's album.

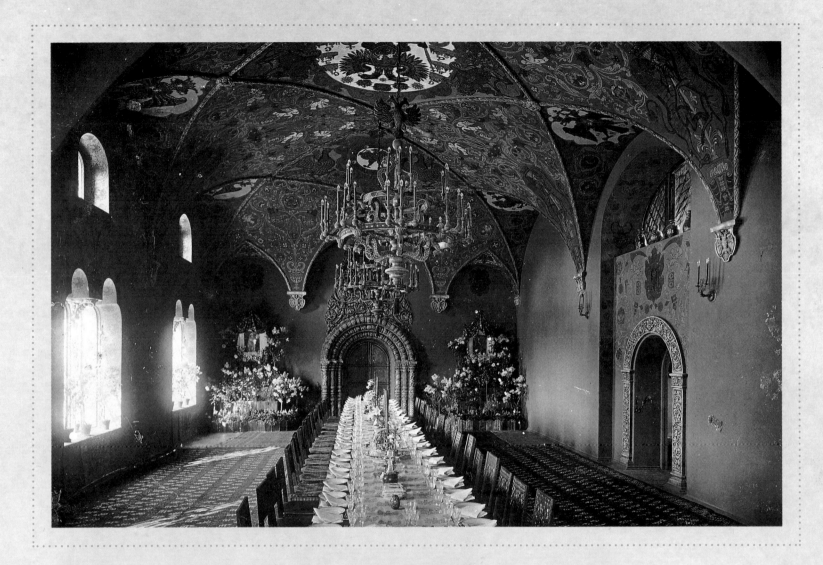

Banqueting in the Federovsky Gorodok, 1913.

The Federovsky Gorodok was built in the Neo-Russian style for the three-hundreth anniversary of the Romanov dynasty in 1913. It was used as the barracks for the Tsar's bodyguard and as a hospital in World War I.

Alexandra relaxing in 1913.

Roses and lilies at her elbow, Alexandra poses informally.
She is wearing a kaftan. This picture is from Alexandra's album.

Nicholas, at ease.

Away from the cares of state, Nicholas enjoys his pipe in the fresh air. Some of his pipes were made of amber. This one could be jet. Nicholas had them made specially for him by J. Sommer & Co. in Paris.

Nicholas and Alexei feeding an elephant.

The children had a menagerie at Tsarskoe Selo.
This photograph is by Tsarina Alexandra, herself a keen
photographer.

The Grand Duchess Maria, 1915.

Maria leans against a wicker chair on the terrace at Tsarskoe Selo.
The pictures on these two pages are from the Tsarina's album.

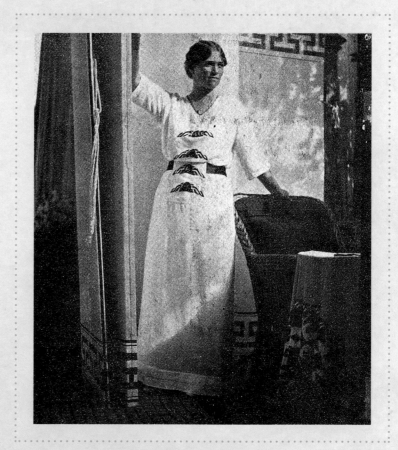

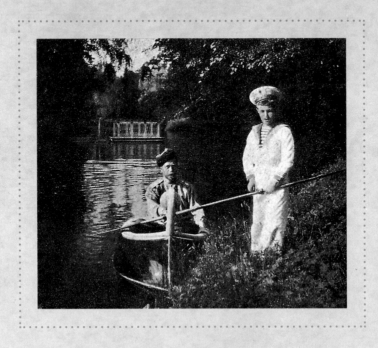

A rowing lesson in 1914.

The lake in the Tsarskoe Selo grounds, on which it was large enough to boat.
Alexei uses his father's oar to steady the canoe at the lakeside. The Tsar enjoyed
physical activity of all sorts, especially walking, bicycling and rowing.

Tennis: mixed doubles.

Anastasia and partner play against one of
her sisters and her partner. Anastasia's sister is
about to serve. This photograph is by
Tsar Nicholas.

·ABOVE·

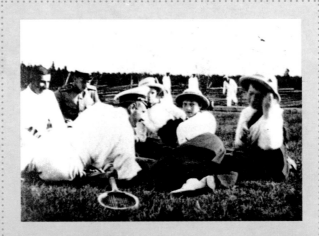

Resting after a game of tennis.

Three of the Grand Duchesses, Olga,
Tatiana and Anastasia, relax on the grass.
It is likely that this photograph was taken
by the missing Grand Duchess, Maria.

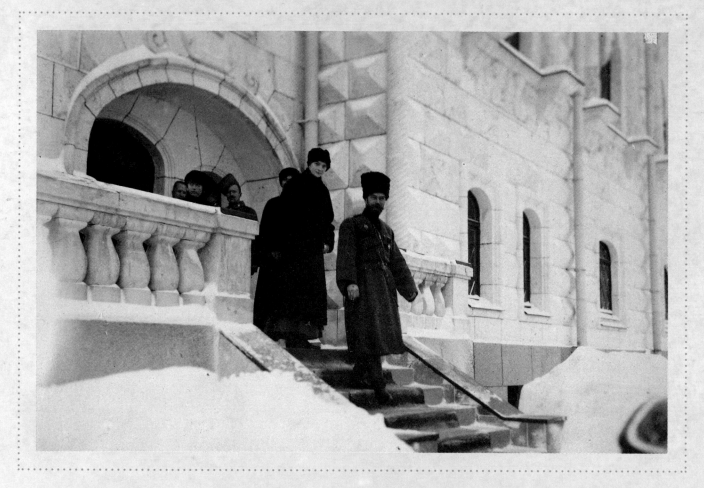

Leaving the Federovsky Gorodok.

On a snowy winter's day, not long before the abdication, Nicholas and his daughters set
off from Tsarskoe Selo by car. From the Grand Duchess Maria's album.

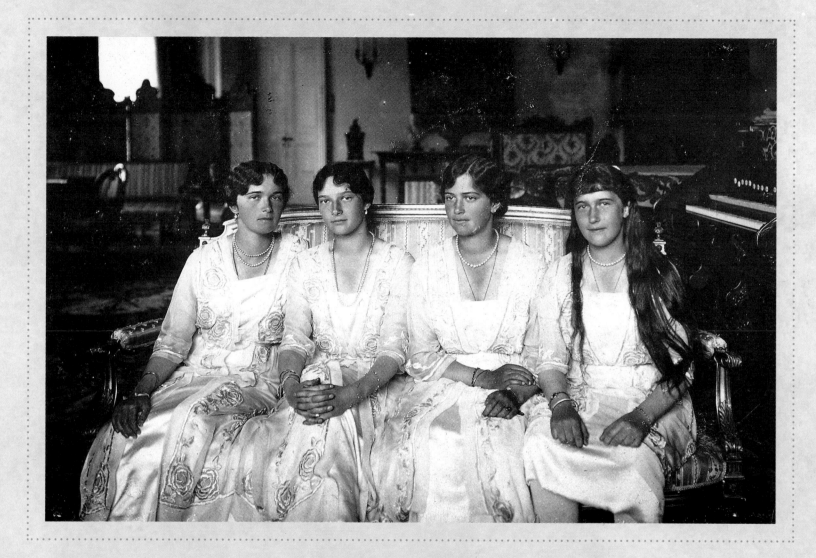

The four Grand Duchesses.

Pearls about their necks and bracelets on their wrists, the Tsar's daughters pose in evening gowns in
one of the salons. The furniture is French. Family concerts would be held here. The organ behind the girls
is stacked with well-thumbed sheet music. All the Tsar's daughters learnt to play the piano, with varying
degrees of success. Tatiana was technically the best player. Both this and the following photograph
come from Maria's album.

The Tsarina and her daughters in a troika.

Warmly wrapped with fur muffs and rugs, Alexandra and her daughters prepare to dash through the snow in a troika (a Russian sleigh drawn by three horses). Silver bells decorate the horses' harness. On the left are the initials of Nicholas and Alexandra, possibly in lights.

Tsar Nicholas on the Tsarina's balcony.

This photograph from the Tsarina's album shows Nicholas leaning on his bayonet. He is wearing his Cossack coat and black hat.

Grand Duchess Maria.

Dressed to face winter, Maria walks in the grounds of Tsarskoe Selo Imperial Park as the snow is melting. This photograph and the subsequent one are from Grand Duchess Maria's album.

Princess Irina Alexandrovna.

Holding her long rope of pearls,
the girls' cousin stares into the camera.
Irina's husband, Prince Yusopov, was
responsible for the murder of Rasputin.
Alexandra never forgave him, and after
Rasputin's death Prince Yusopov was exiled
from Petrograd (St Petersburg).

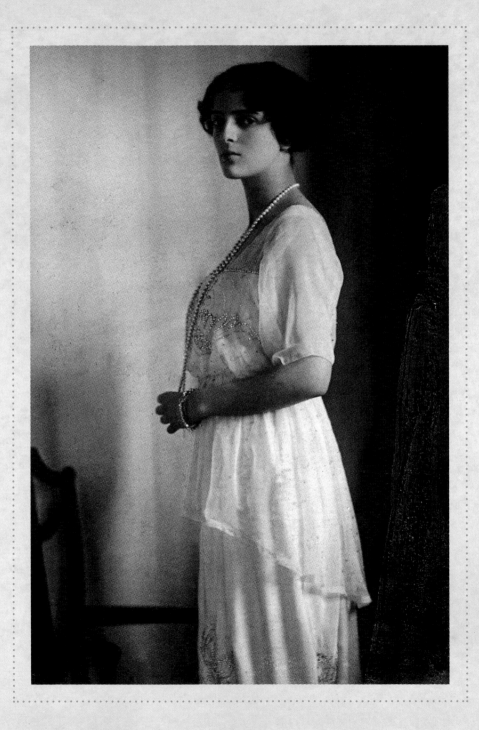

Imperial Yachts

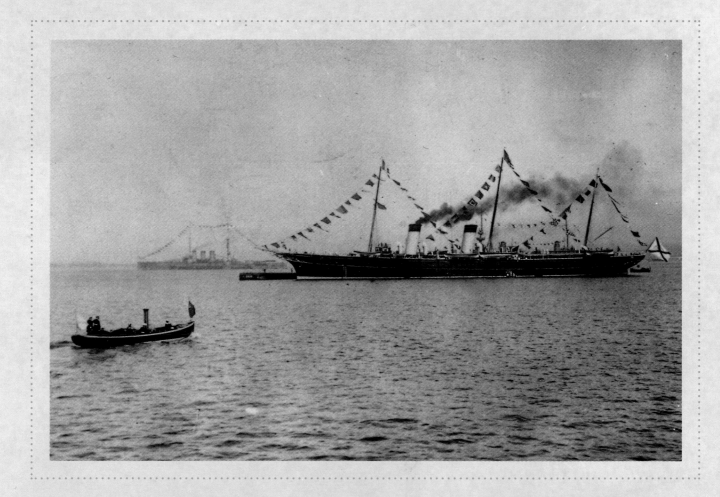

The 'Standart'.

The Romanovs possessed a fleet of yachts, of which the *Standart* was the best equipped. When the family were not staying at their palace in Livadia, they loved nothing better than cruising in the Gulf of Finland aboard the *Standart*.

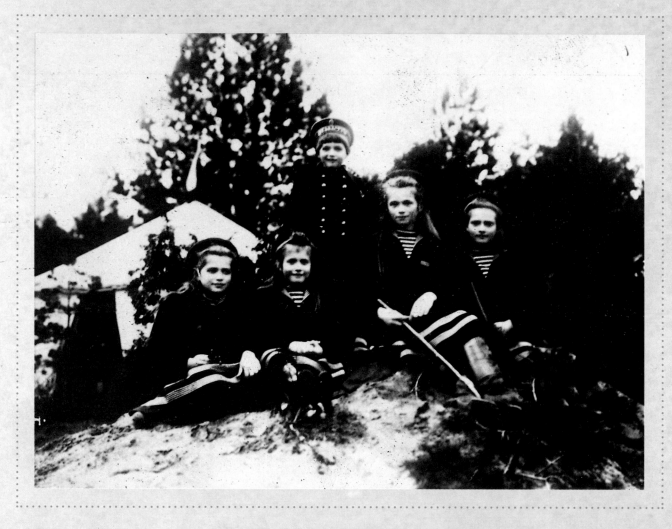

The Skerries in Finland.

The Imperial children come ashore. On one occasion the *Standart* hit a rock,
and it was feared it might sink. The family were transferred to a sister ship, the *Polar Star*,
to continue their cruise.

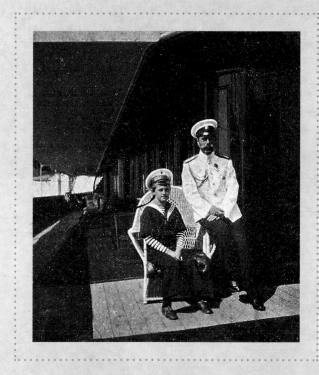

Tsar Nicholas and Alexei.

On board the *Standart*, in 1914. Alexei's cap is emblazoned with
the ship's name.

On deck of the 'Standart'

Grand Duchess Maria passing a lifeboat. Both these pictures come
from the Tsarina's album.

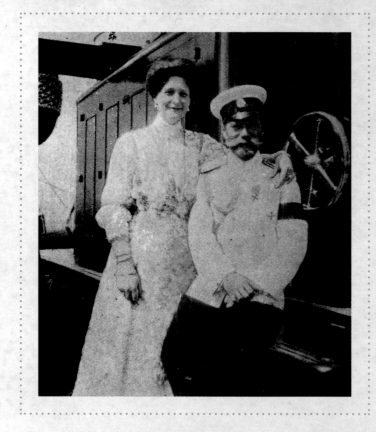

Nicholas and Alexandra.

The Tsar and Tsarina in holiday mood on one of their yachts.

Horseplay.

One of the Grand Duchesses – said to be Maria – has fallen
into the water. She is being helped out by a sister and two of the Tsar's
adjutants. The adjutant on the right is Prince Igor Constantinovich,
who died with Alexandra's sister Ella in the Alapaevsk mine in 1918.
A launch lies at anchor in the background.

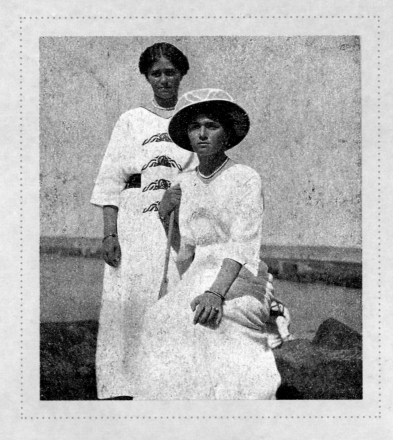

At Alexandria-Peterhof in 1915.

Part of each summer was spent in the Alexandria Palace in Peterhof,
on the coast of the Gulf of Finland. Here the Grand Duchesses Olga (seated)
and Maria pose for a photograph. Olga seems to be holding
an oar. This photograph comes from the Tsarina's album.

The Palace Hospital

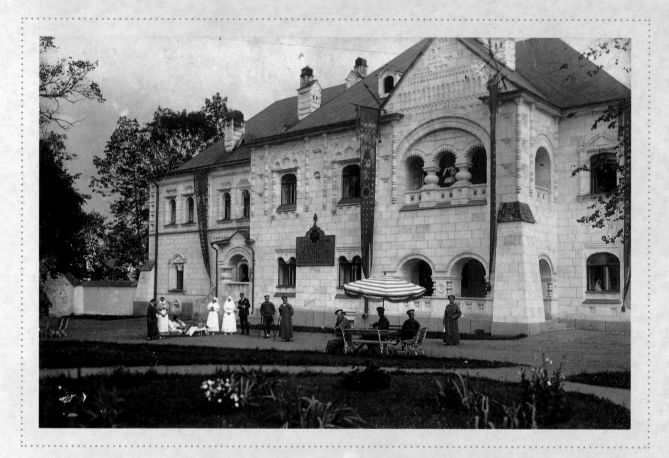

The Palace Hospital.

This sequence of fifteen pictures comes from Maria's album. The first shot of World War I was fired on the bridge at Sarajevo, when Archduke Franz-Ferdinand was assassinated. Russia was drawn reluctantly into the war to protect the Slavs against the Austro-Hungarian and German empires. As part of their contribution to the war effort, the Tsarina set up an evacuation centre in Tsarskoe Selo for about 85 hospitals. She and her daughters worked from the Federovsky Gorodok in the grounds of Tsarskoe Selo. This photograph is taken to the left of an ornamental lake.

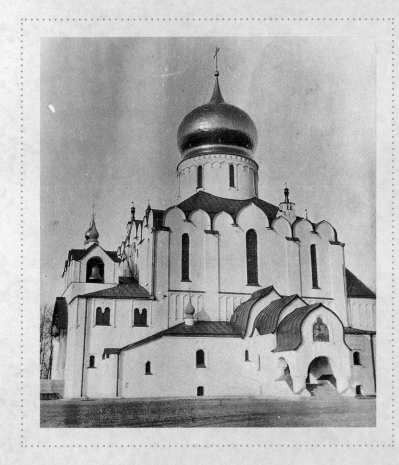

The cathedral of St Theodore.

Towards the end of her life, Alexandra became devout almost
to the point of fanaticism. She had St Theodore's Cathedral built in the
Imperial park of Tsarskoe Selo in order to pray for Alexei's health.
It was linked to the Palace Infirmary, and priests from the church
visited soldiers at the hospital.

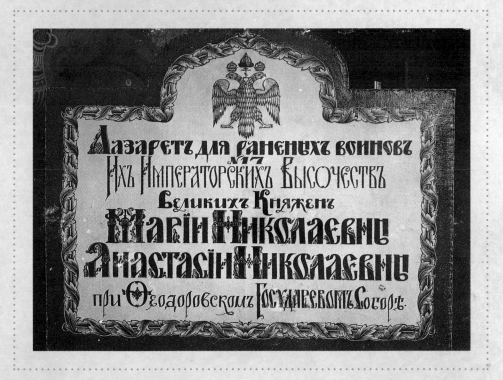

Hospital plaque.

The Russian text reads: 'Convalescent Home for Wounded
Soldiers No. 17. Sponsored by their Imperial Highnesses, the Grand
Duchesses Maria Nikolaevna and Anastasia Nikolaevna. Attached
to the church of St Theodore.'

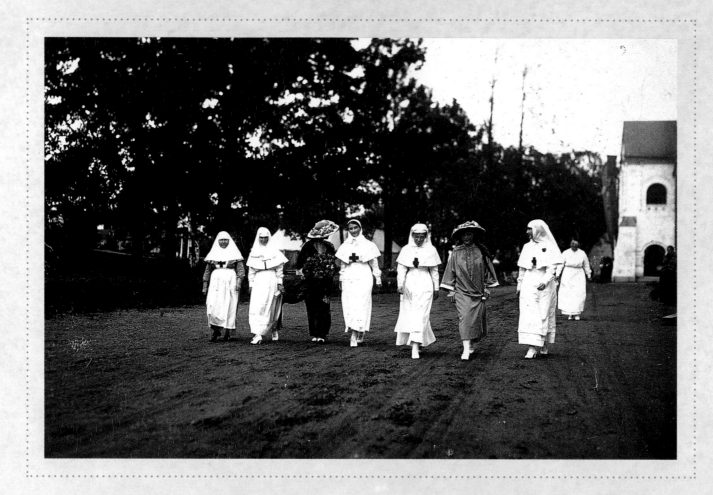

Anastasia and Maria chat to nurses who work with their older sisters.

The Tsarina, Olga and Tatiana nursed in this hospital, gaining their Red Cross certificates.
It was not easy work; they assisted in operations, such as amputations. Maria and Anastasia were
considered too young to nurse, so they sponsored the hospital and confined themselves
to visiting the officers.

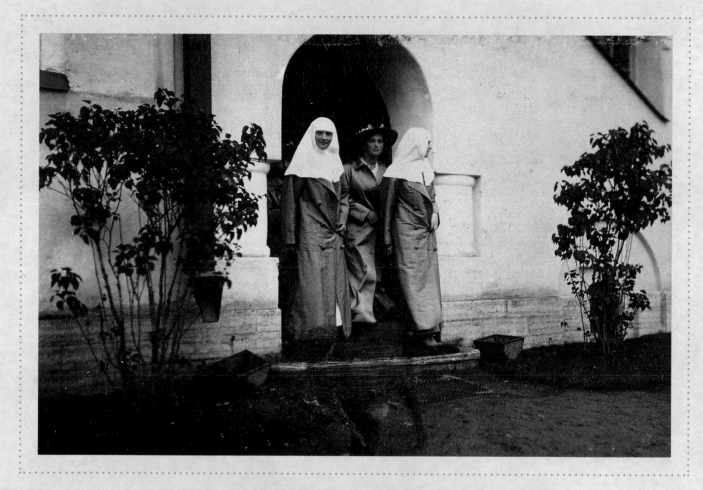

The Grand Duchesses going about their duties, 1915.

(Left to right) Anastasia is just visible behind Olga who is wearing her nurse's uniform. Next to Olga is Maria and then Tatiana, in nurse's uniform. With a white veil caught beneath the chin, wimple-fashion, the Red Cross uniform was very similar to a nun's habit.

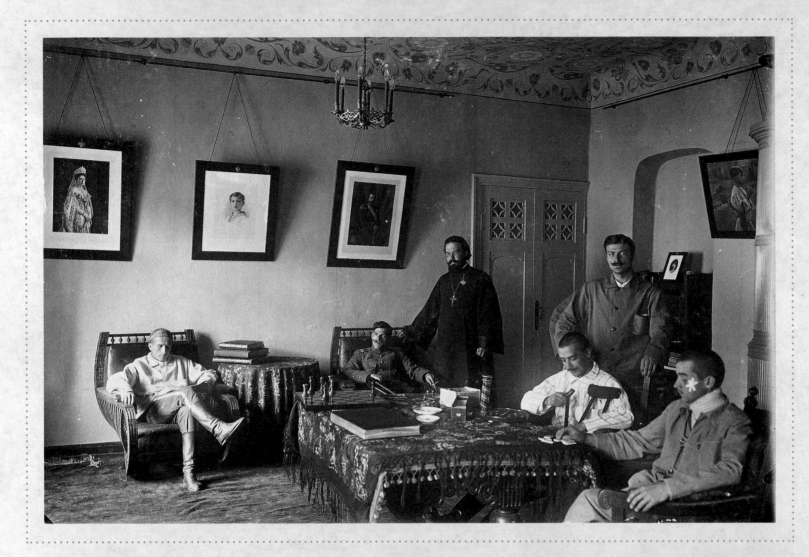

Wounded officers and a priest at the Palace Hospital.

Conditions for these officers are far from spartan. Portraits of the Imperial Family adorn
the walls, the ceiling is painted with roses and acanthus leaves, and the floor and table are
covered with rich carpets. Smoking was permitted in this hospital as the ashtrays testify.

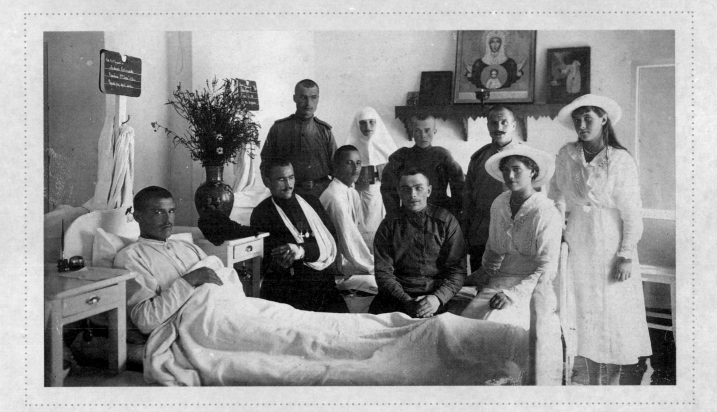

Visiting the wards.

Maria and Anastasia talk to bedridden soldiers. There are flowers on the bedside tables and holy icons on the wall. This soldier has pen and ink to hand. Across the left-hand corner of the ward, reaching almost to the ceiling, is a white tiled stove that heated the room.

· A B O V E ·

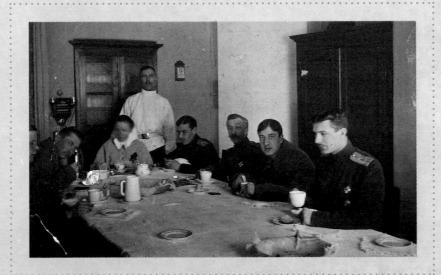

Tea in the hospital dining-room.

The Head Nurse supervises. On the wall, to the left of the tiled stove, is a tear-off calendar.

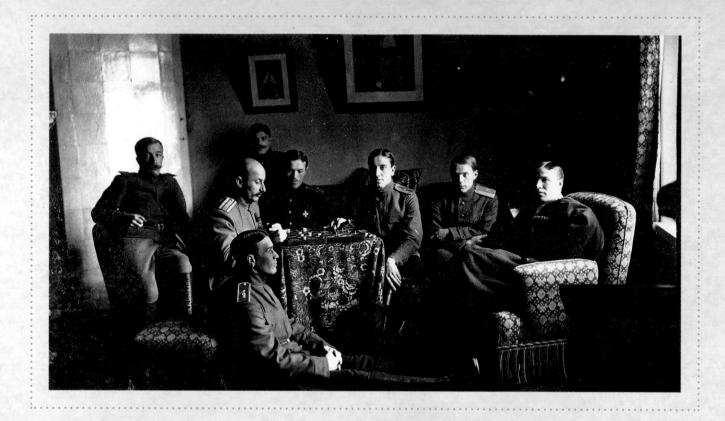

A game of draughts in the sitting-room.

Overlooking these officers is a photograph the Tsarina had taken when she and the Grand Duchesses Olga and Tatiana gained their Red Cross certificates.

· A B O V E ·

Recreation for wounded officers.

Two officers, one in a dressing-gown, playing billiards. Even the billiard-room has a decorated ceiling and curtains with pelmets. Another white stove is positioned to the right of the picture.

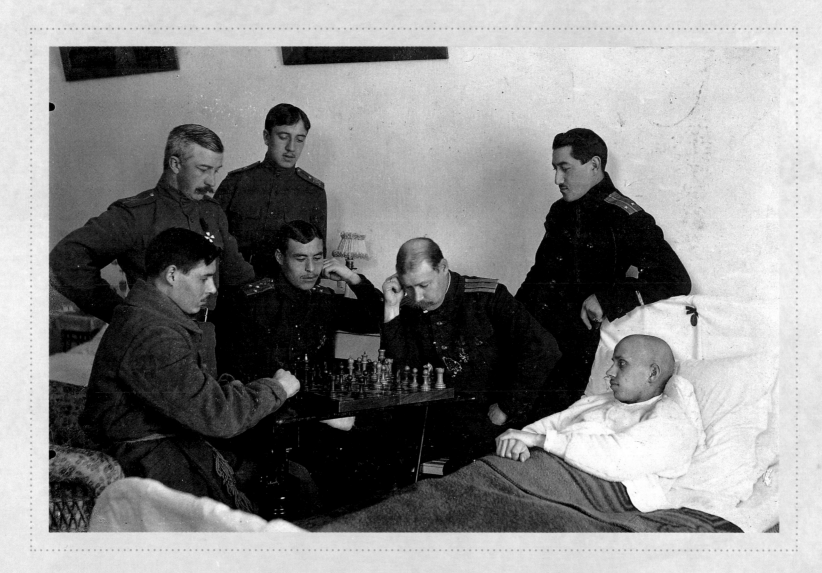

Chess at a less able-bodied officer's bedside.

Nurses Tatiana and Olga.

The nurses helped to wash and dress the patients' wounds and feed the officers if necessary. This officer has fruit at his bedside.

· R I G H T ·

The Senior Nurse and the hospital cat.

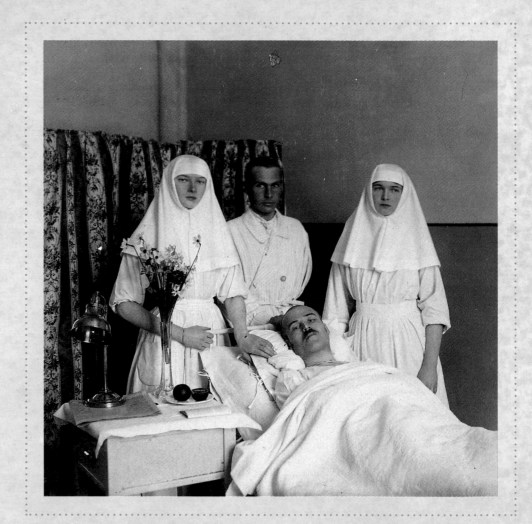

Hospital administration.

A glimpse of Dr Musin-Pushkin's office during World War I. The telephone on the left marks out
this office as one of the best equipped in Russia. It was probably the evacuation centre.

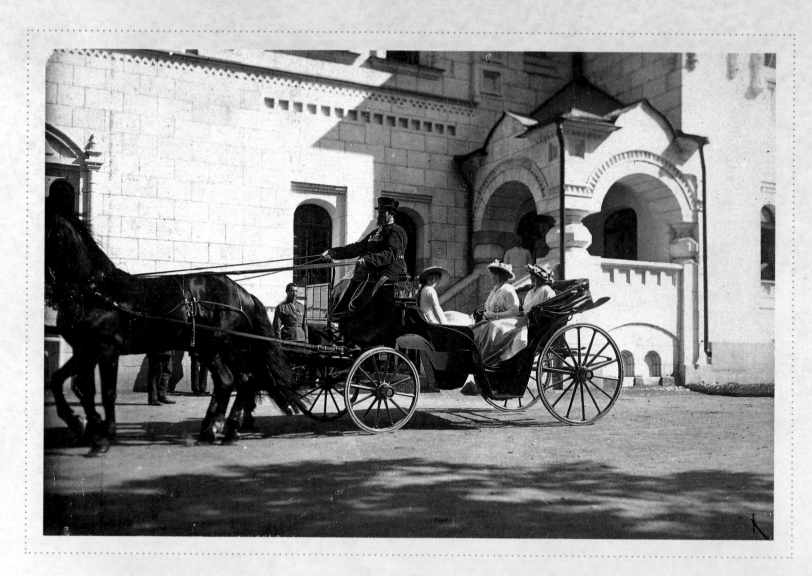

The Tsarina and two Grand Duchesses leave the Palace Hospital.

Their duties over for the day, Alexandra and her two youngest daughters, Maria and Anastasia,
drive off in a carriage.

Death of a Dynasty

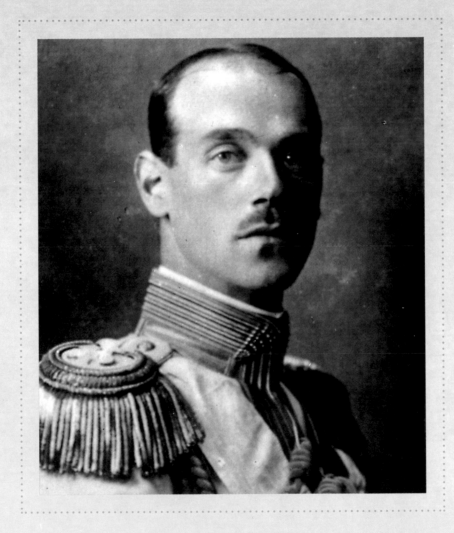

The Tsar's brother, the Grand Duke Mikhail.

When Nicholas was forced to abdicate in 1917, he resigned the throne on behalf of his son, too, and named his brother, the Grand Duke Mikhail, as his successor. However, realizing that the tide had turned for ever against the Romanovs, within 24 hours Mikhail had renounced his right to the throne of Russia, thus ending over 300 years of Romanov rule. Determined to wipe all Romanovs from the face of the earth, the Bolsheviks shot Grand Duke Mikhail in Perm, six days before they killed Nicholas and his family in Ekaterinburg.

Shaved heads 1917.

In the early days of their imprisonment, the family remained at Tsarskoe Selo, where Alexei and
his sisters caught measles. Their hair started to fall out, so their heads were shaved. (Left to right) Anastasia, Olga,
Alexei, Maria and Tatiana. The photographs, which seem to prefigure the family's future, were taken by one of the
children's tutors, at the children's urging. Alexandra, who insisted her children wore hats after their heads were
shaved, is said to have felt faint when she saw them.

Nicholas and Alexandra's daughters in the early days of their captivity.

With their father, the children dug a new vegetable garden in the grounds of the Alexander Palace, Tsarskoe Selo, in 1917. They hoped its cultivation would help eke out their rations. This photograph shows them resting with some of their pets. Tatiana had the Pekinese called Jemmy. There was a bulldog, Ortipo, as well as the Tsarevich's spaniel, Joy.

· RIGHT ·

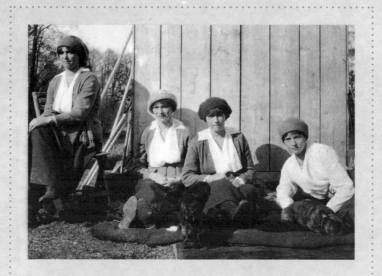

The Governor's House, Tobolsk, 1917–18.

The family continued to take photographs of each other almost to the end. The picture below was taken in Tobolsk before conditions were made more punitive. Alexei is swinging, flanked by two of his sisters. Nicholas Romanov, ex-Tsar, stands smoking on the right.

The compound of the Governor's House, Tobolsk, 1917.

Alexei practising archery. The family were allowed to exercise in the compound at Tobolsk,
which was boarded over because of the mud.

The last photograph of Alexandra and two of her daughters, 1918.

Alexandra suffered from a heart condition, which worsened during the months of incarceration. She spent much of her time in a wheelchair, sewing. When the family and their few faithful retainers were shot in the cellar at Ekaterinburg, the Grand Duchesses did not die immediately.
They had sewn jewels into their corsets, which then acted as flak jackets, causing the bullets to bounce off the gemstones.

The dining-room of the Ipatiev house.

Nicholas Romanov's family ate their last meals in this room. The house belonged to an engineer,
Ipatiev, evicted by the Bolsheviks the day before the family arrived. Ominously, the Bolsheviks renamed it the House
of Special Purpose. The furniture is Victorian in style, heavy and oppressive. On the 17 July 1918, the family were
woken at two in the morning, ordered to dress and wait in the cellar, under the pretext of being moved to a safe place.
There they and their four remaining retainers, including Dr Botkin, were shot and bayonetted to death.

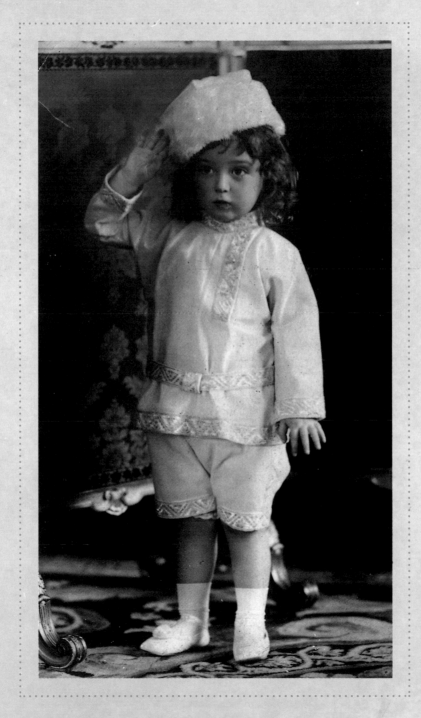

The two-year-old Tsarevich, Alexei, saluting.

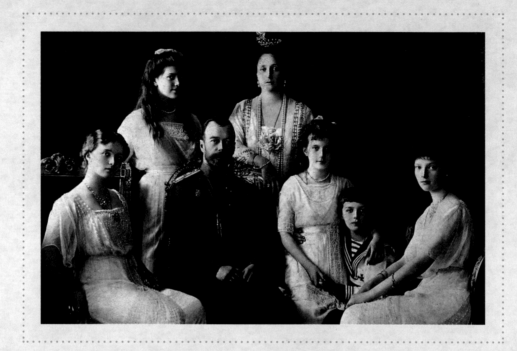

The Imperial Family of Russia.

Standing at the back are the Grand Duchess Maria and the
Tsarina Alexandra. Seated at the front are (left to right) the Grand
Duchess Olga, Tsar Nicholas II, the Grand Duchess Anastasia, the
Tsarevich Alexei and the Grand Duchess Tatiana.

Nicholas's and Alexandra's Signatures